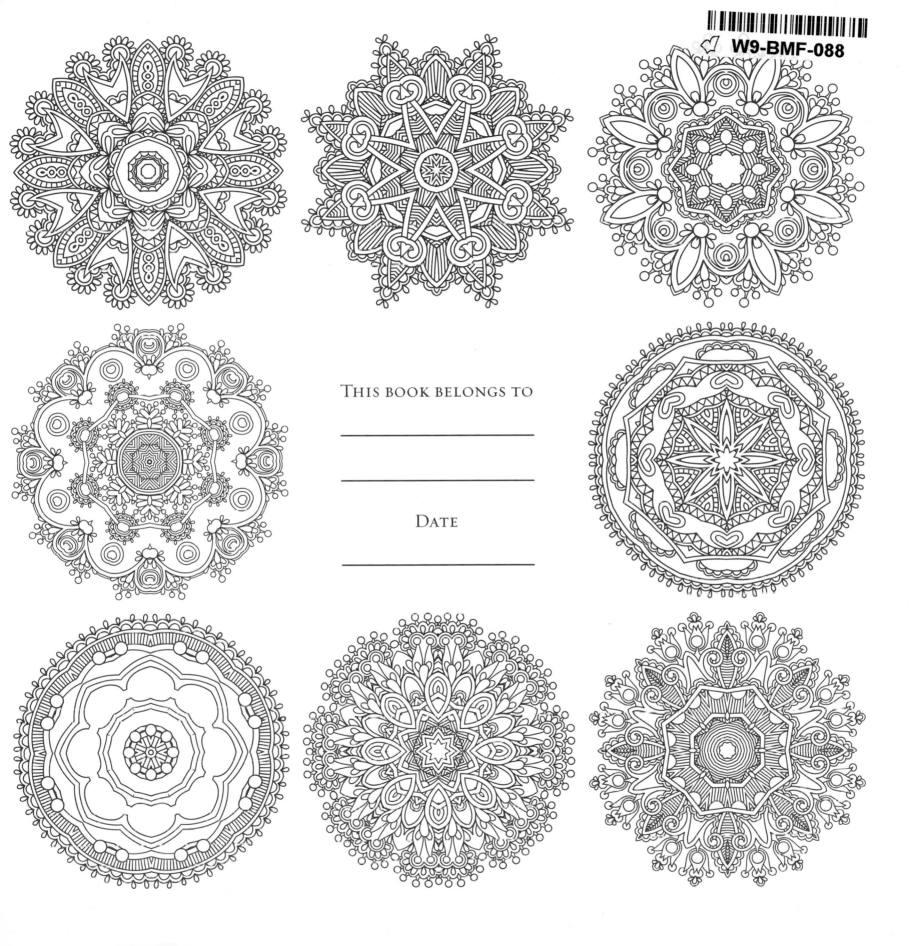

This book belongs to

Date

STERLING ETHOS
New York

An Imprint of Sterling Publishing
1166 Avenue of the Americas
New York, NY 10036

ISBN 978-1-4549-1618-5

Distributed in Canada by Sterling Publishing
c/o Canadian Manda Group, 664 Annette Street
Toronto, Ontario, Canada M6S2C8
Distributed in the United Kingdom by GMC Distribution Services
Castle Place, 166 High Street, Lewes, East Sussex, England BN7 1XU
Distributed in Australia by Capricorn Link (Australia) Pty. Ltd.
P.O. Box 704, Windsor, NSW 2756, Australia

For information about custom editions, special sales, and premium and corporate purchases,
please contact Sterling Special Sales at 800-805-5489 or specialsales@sterlingpublishing.com.

Manufactured in Canada

16 18 20 22 19 17

www.sterlingpublishing.com

Mandala Meditation

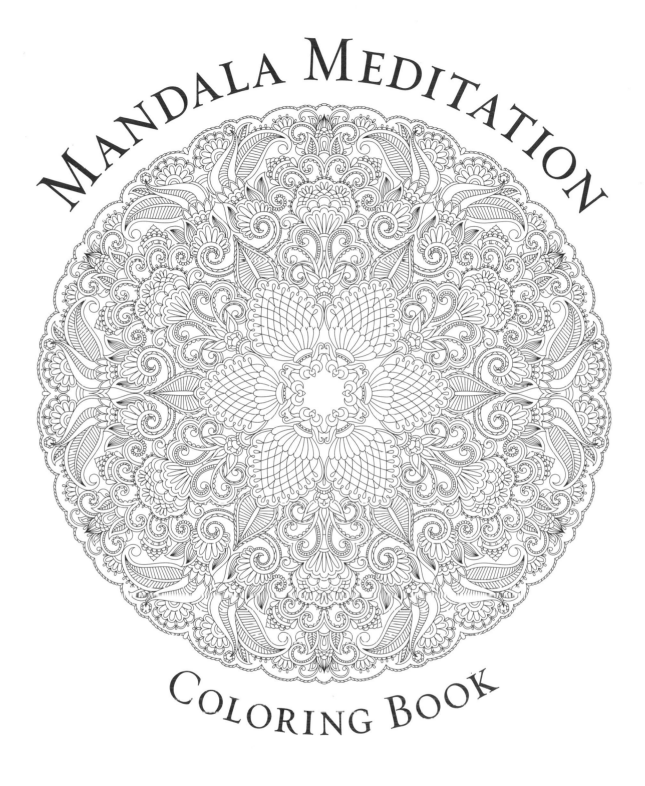

Coloring Book

STERLING ETHOS
New York

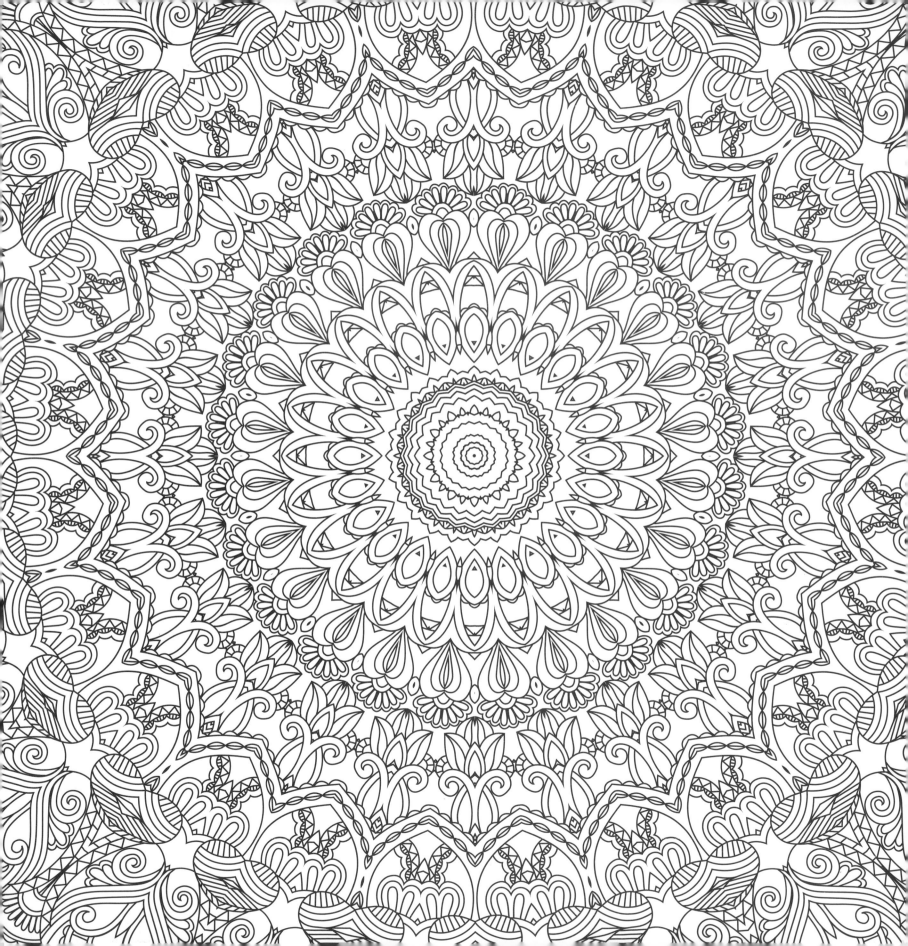

Coloring Mandalas

The mandalic shape is an archetypal, primordial symbol of harmony and unity. Not only has it been replicated by humans in art and architecture since the dawn of civilization, but it also appears in the natural word in phenomena ranging from snowflakes to galaxies.

The word *mandala* comes from the ancient Sanskrit word for "circle." In Hinduism and Buddhism, the traditional mandala is a circular diagram that functions as a graphic representation of the cosmos, a sacred space, and is used in spiritual meditation, healing, and contemplation.

Coloring mandalas can be a meditative, stress-reducing, and creatively rewarding practice for both children and adults. There are 90 mandalas included here in many different styles and patterns for you to color. Whether you use colored pencils or markers, or even paint, choose whichever colors speak to you—there are no wrong combinations— and create your own beautiful, visual diagrams to frame and display, or treasure and store.

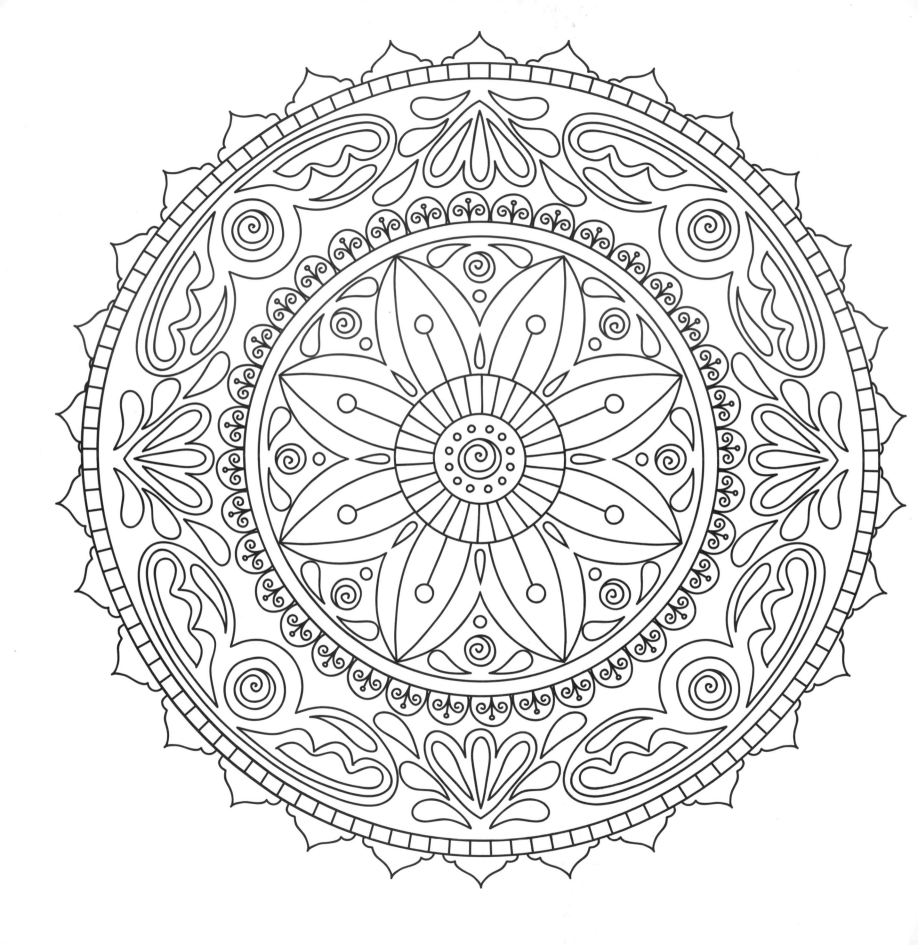

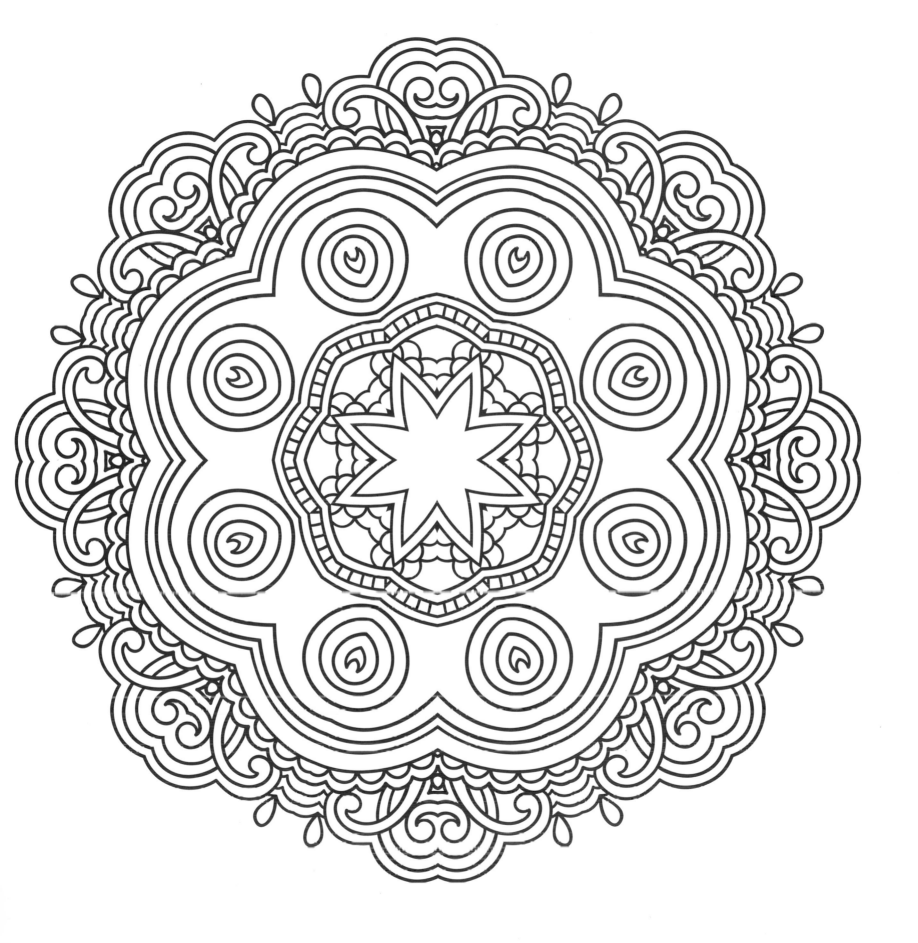

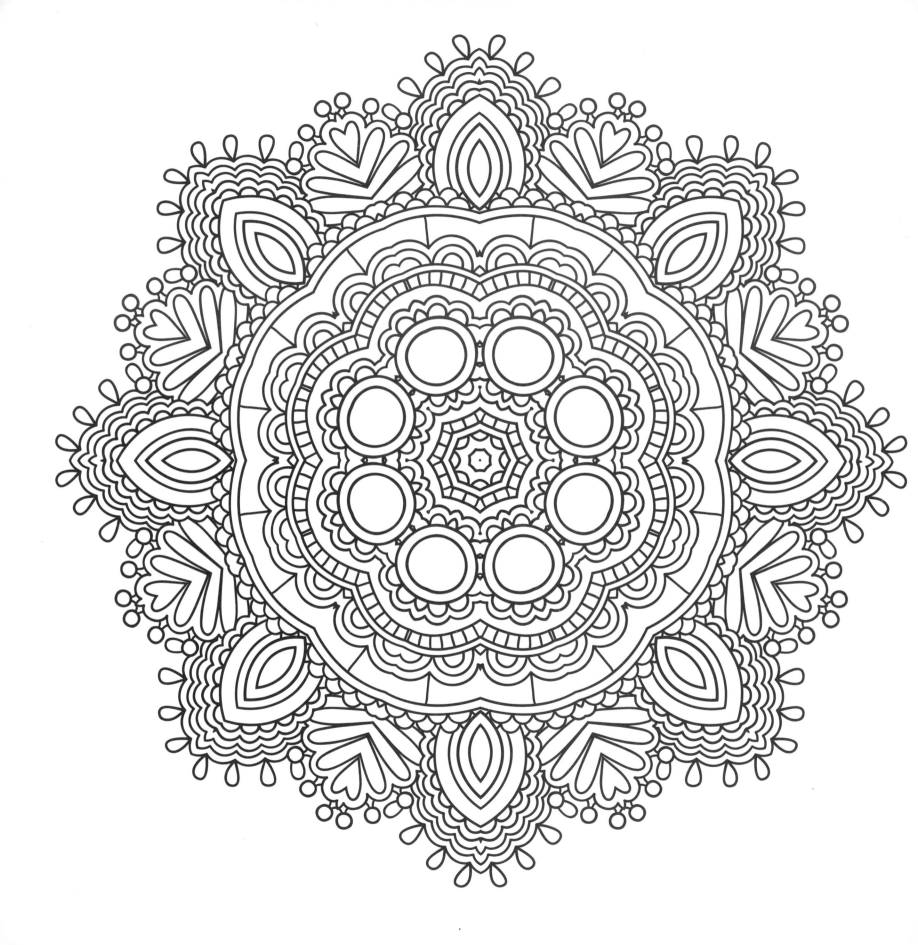

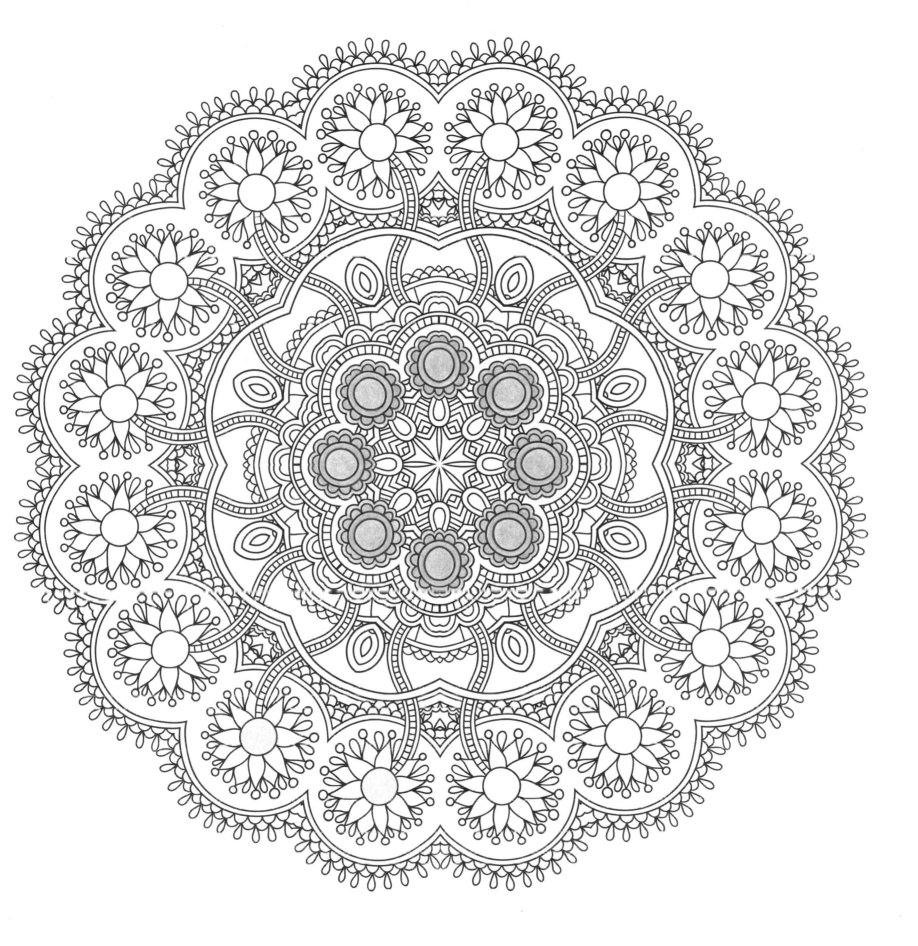

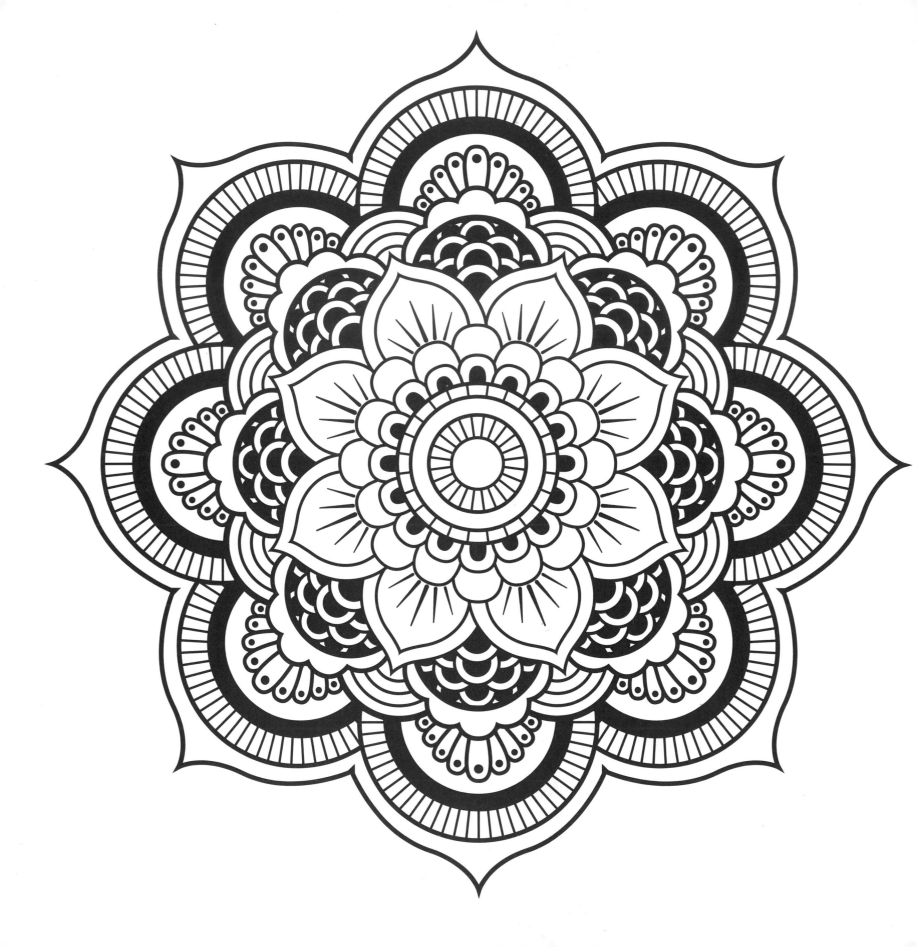

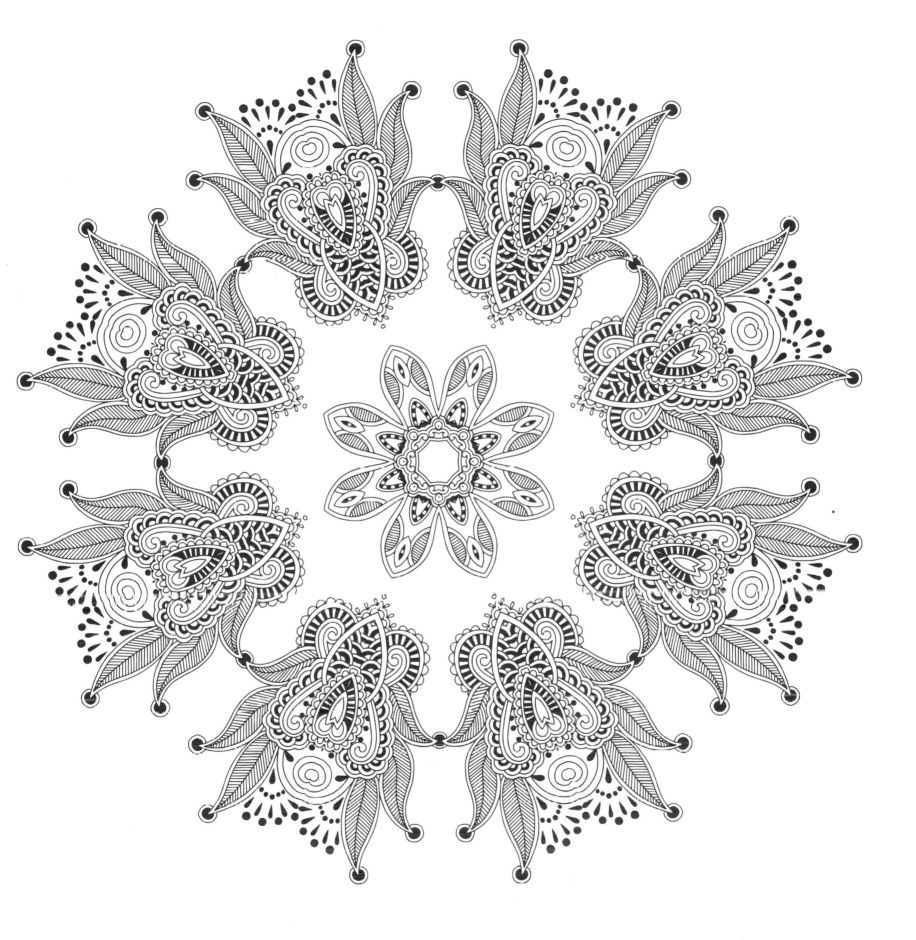

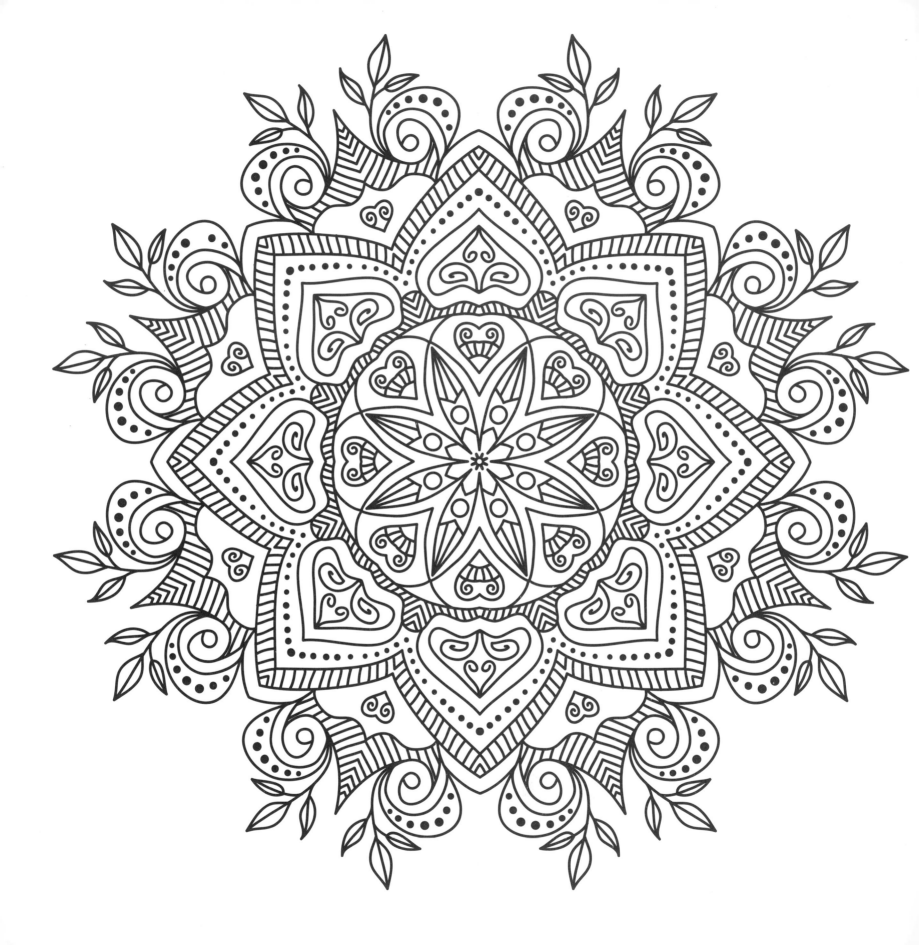

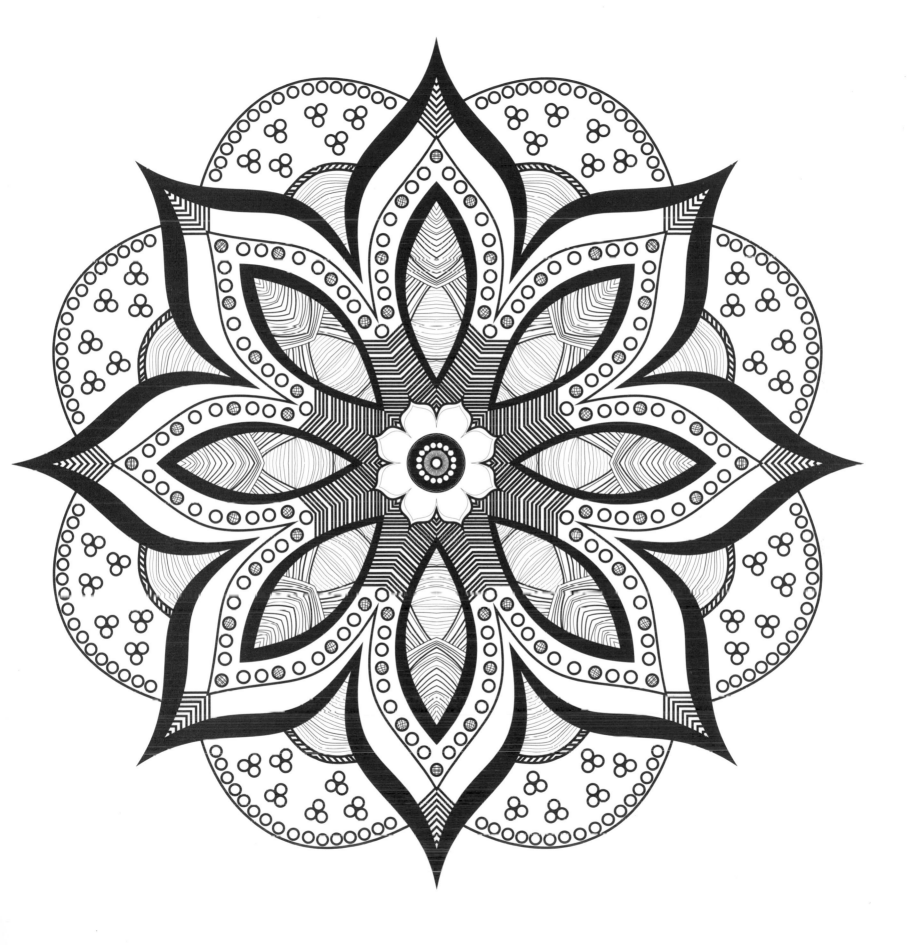

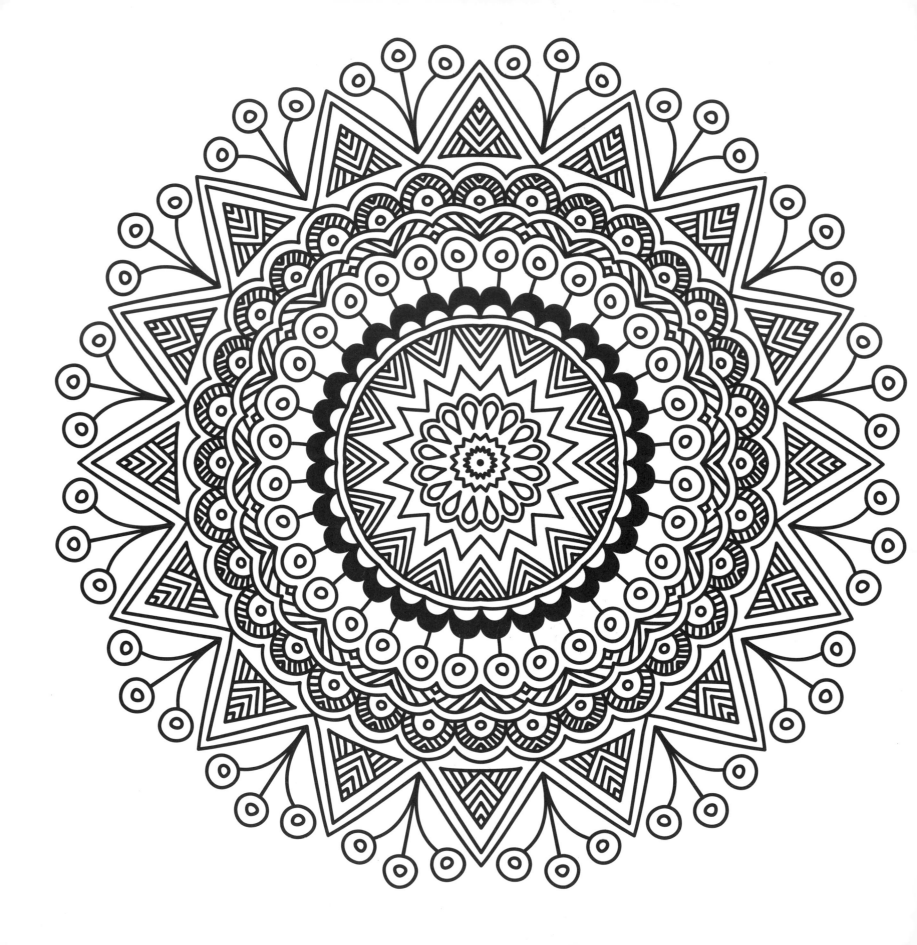

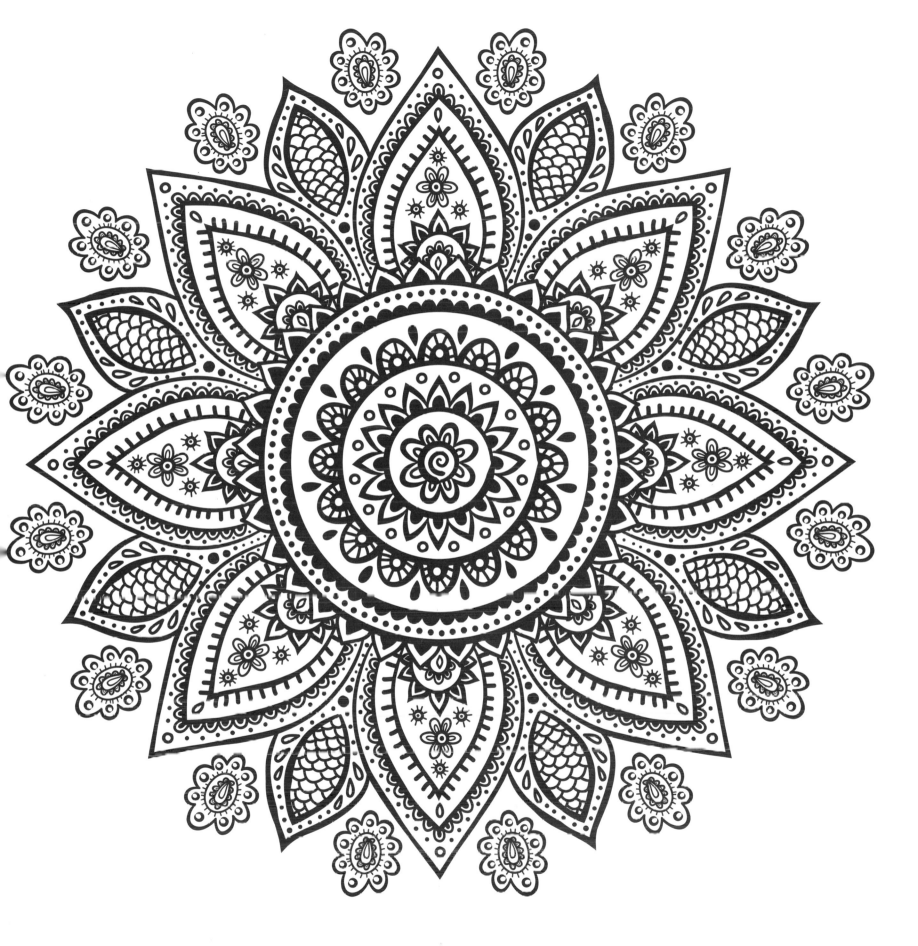

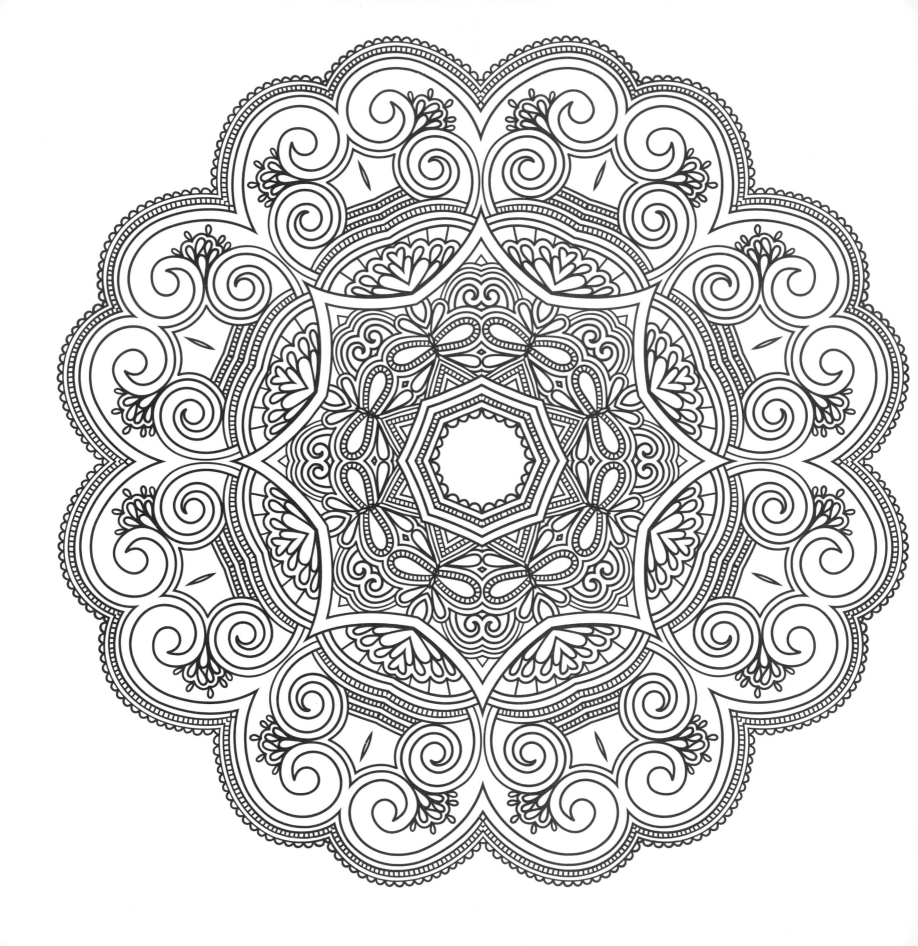

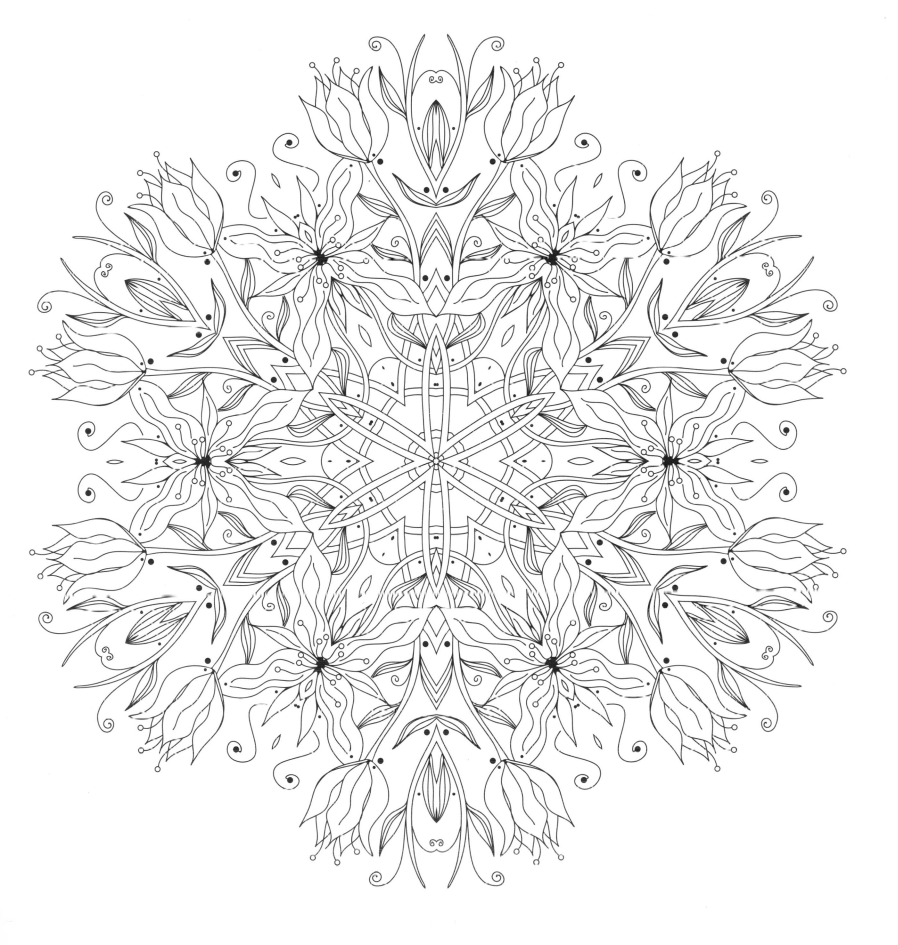

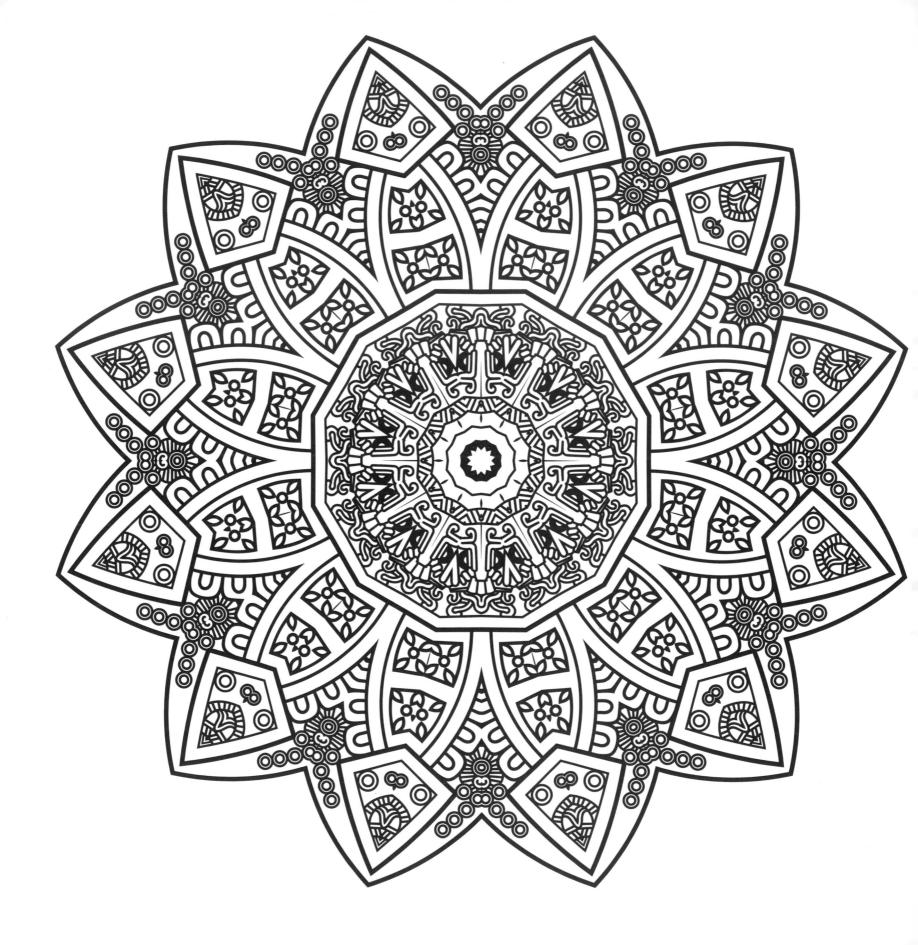

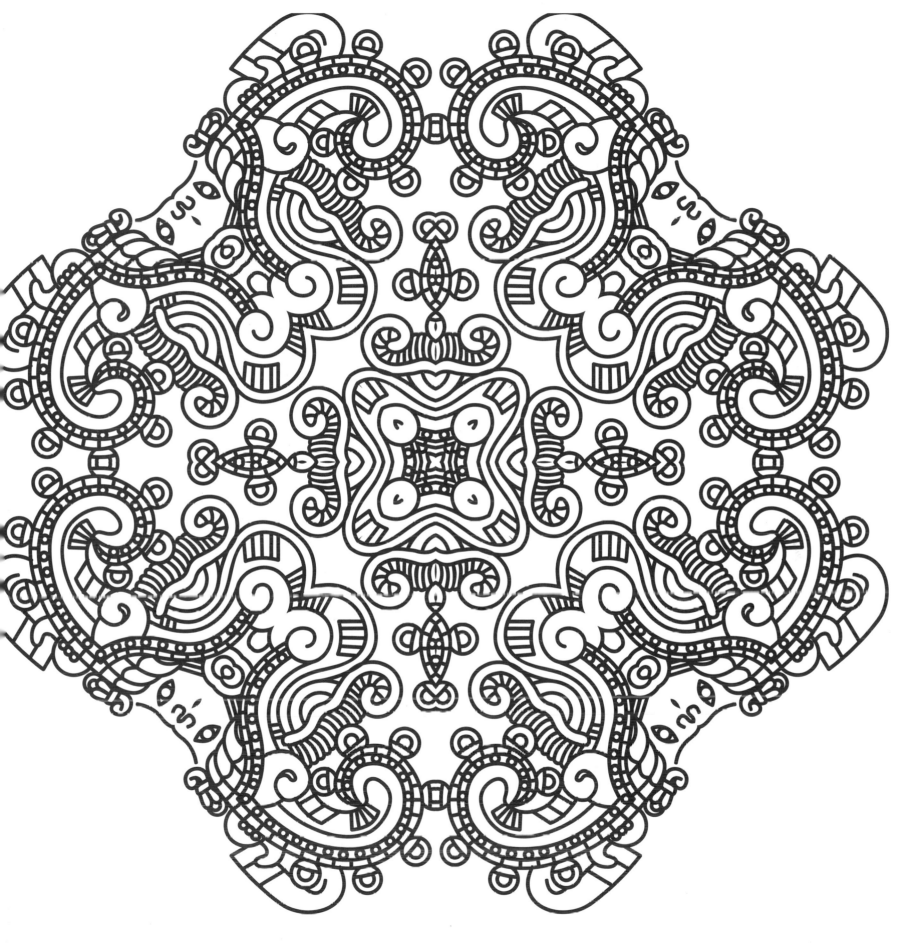

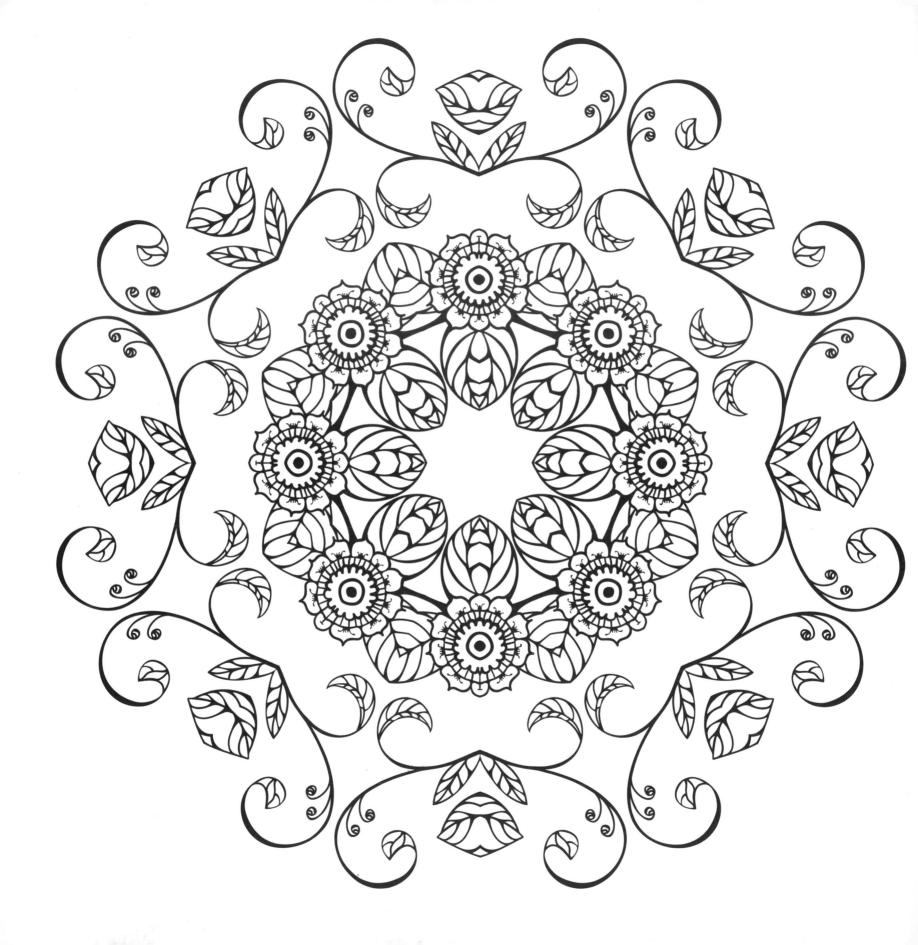

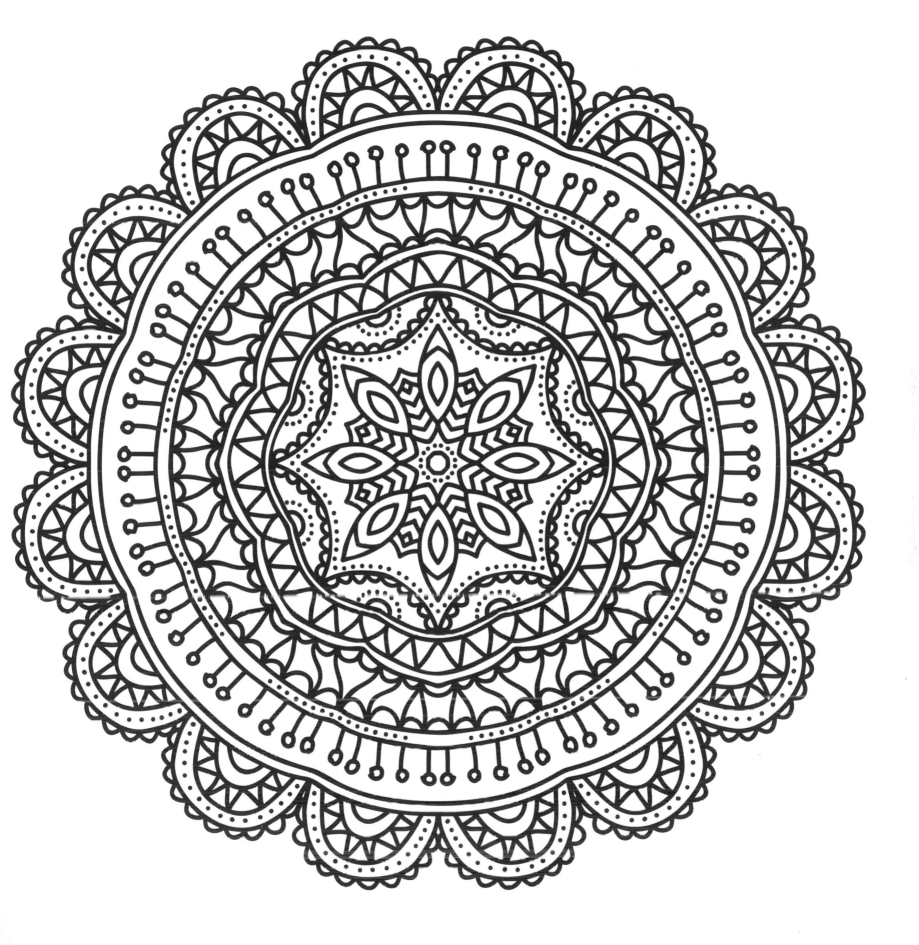

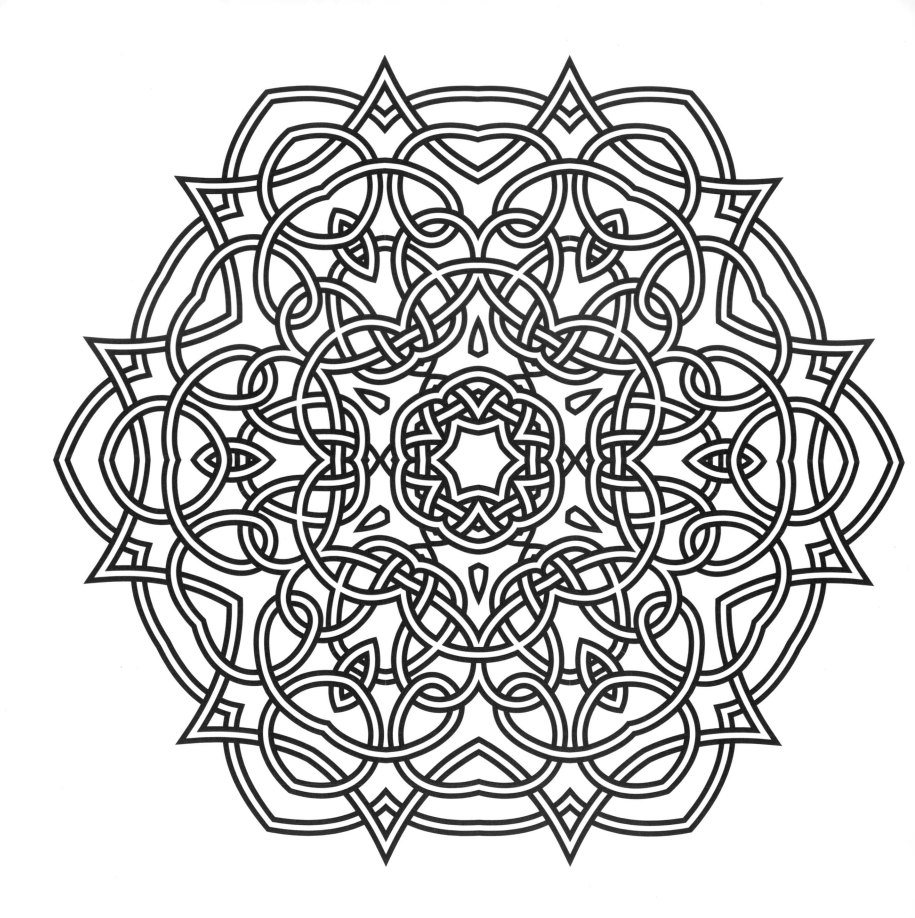

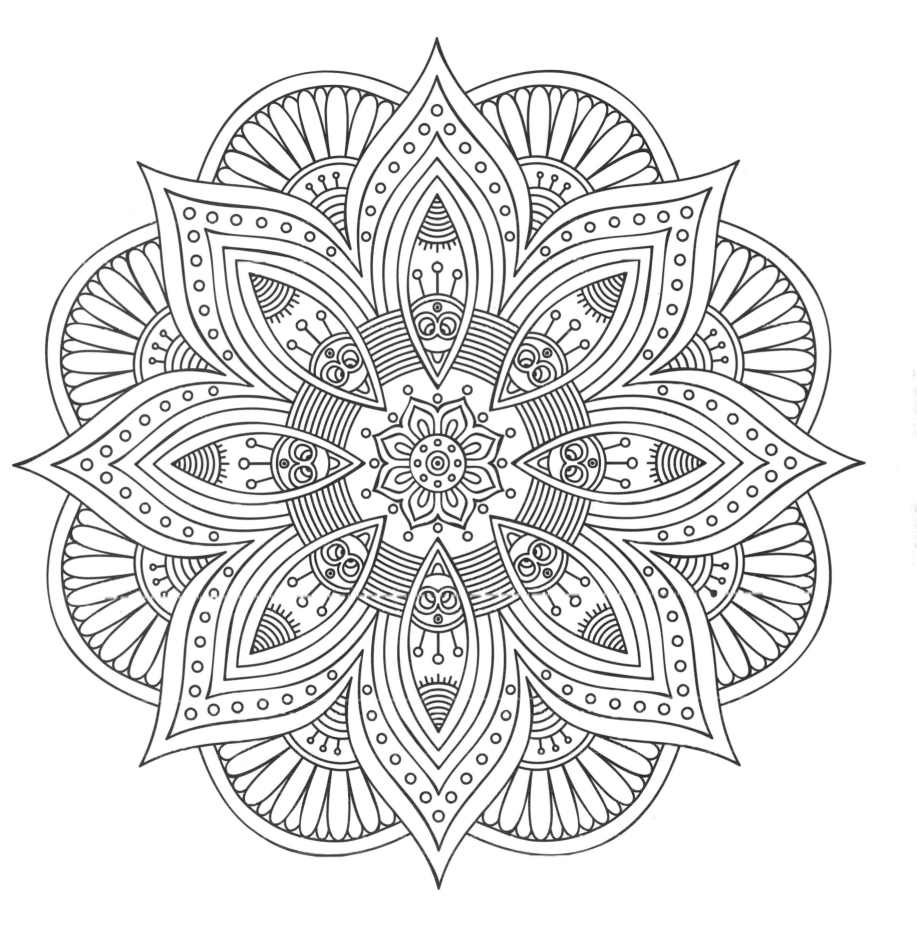

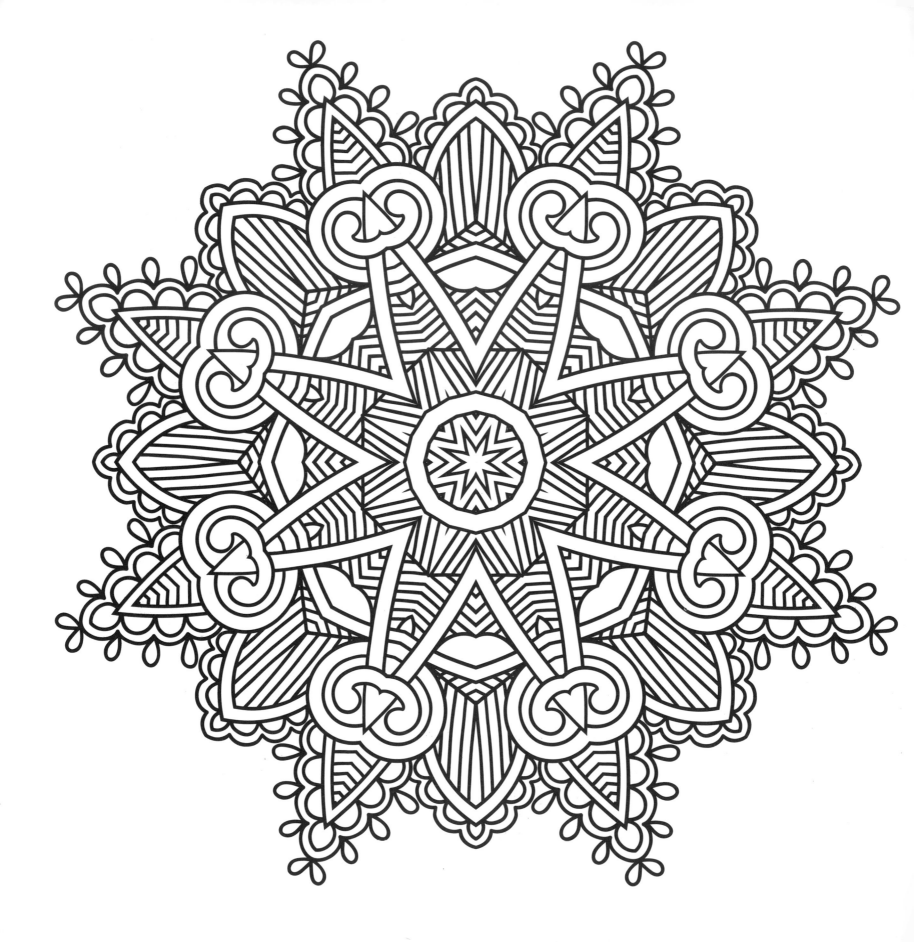

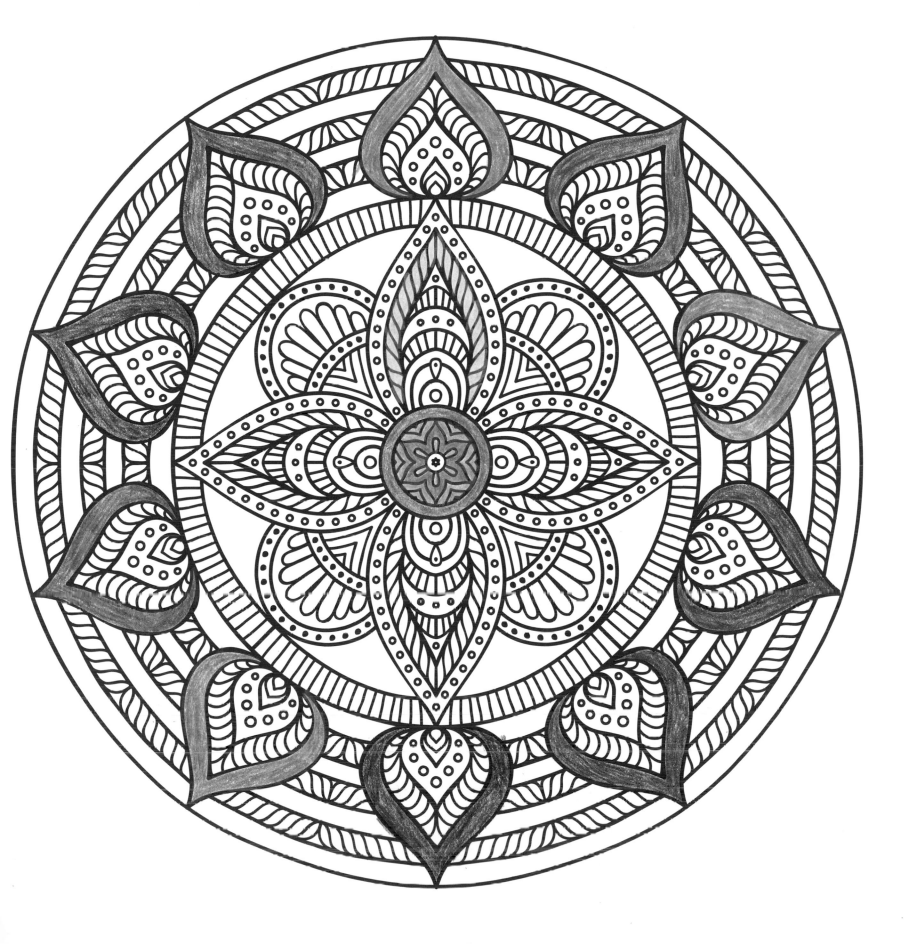

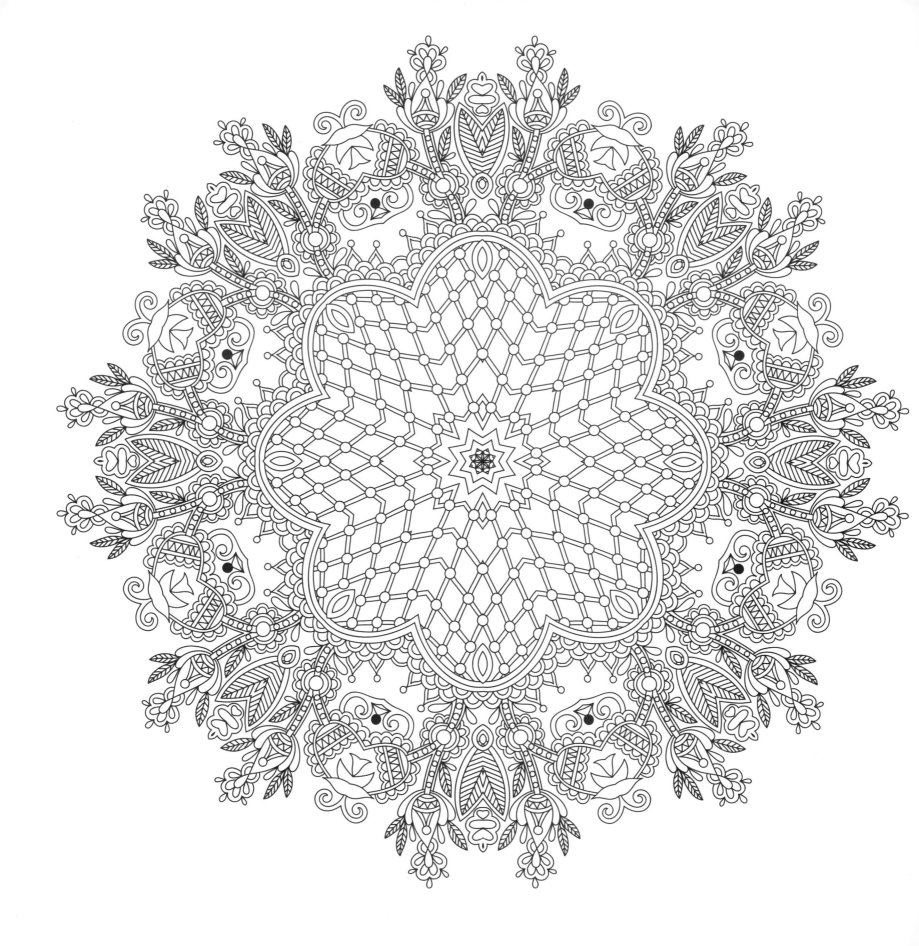

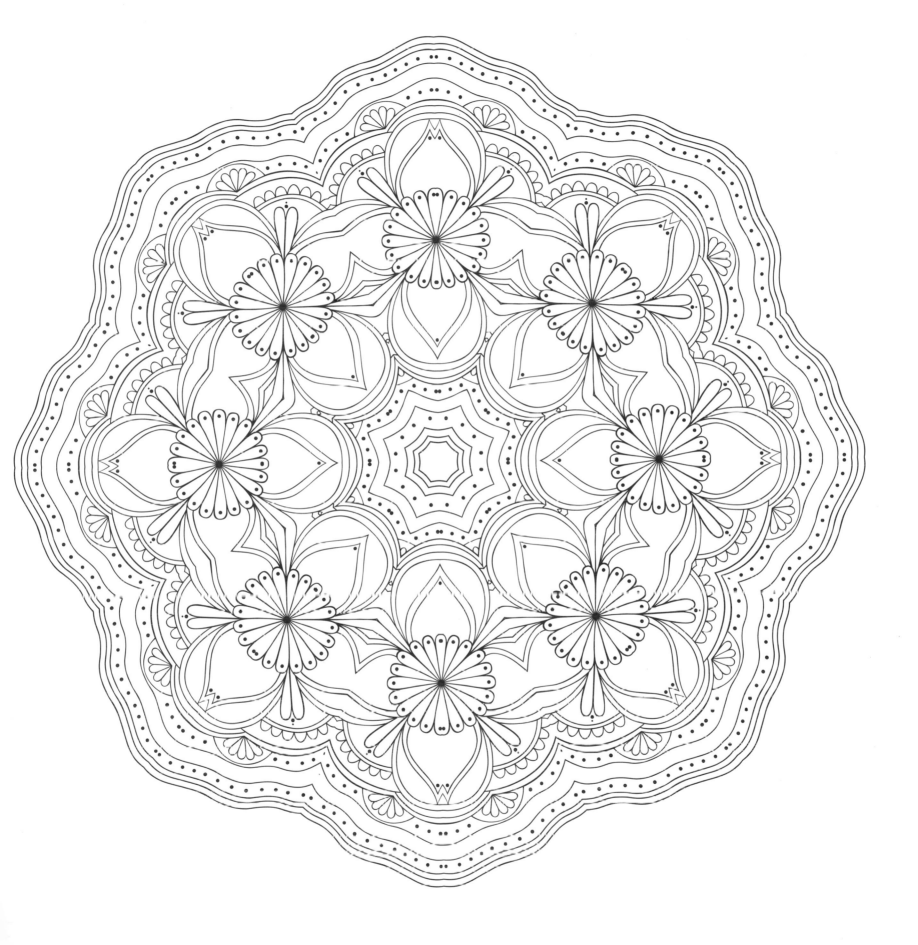

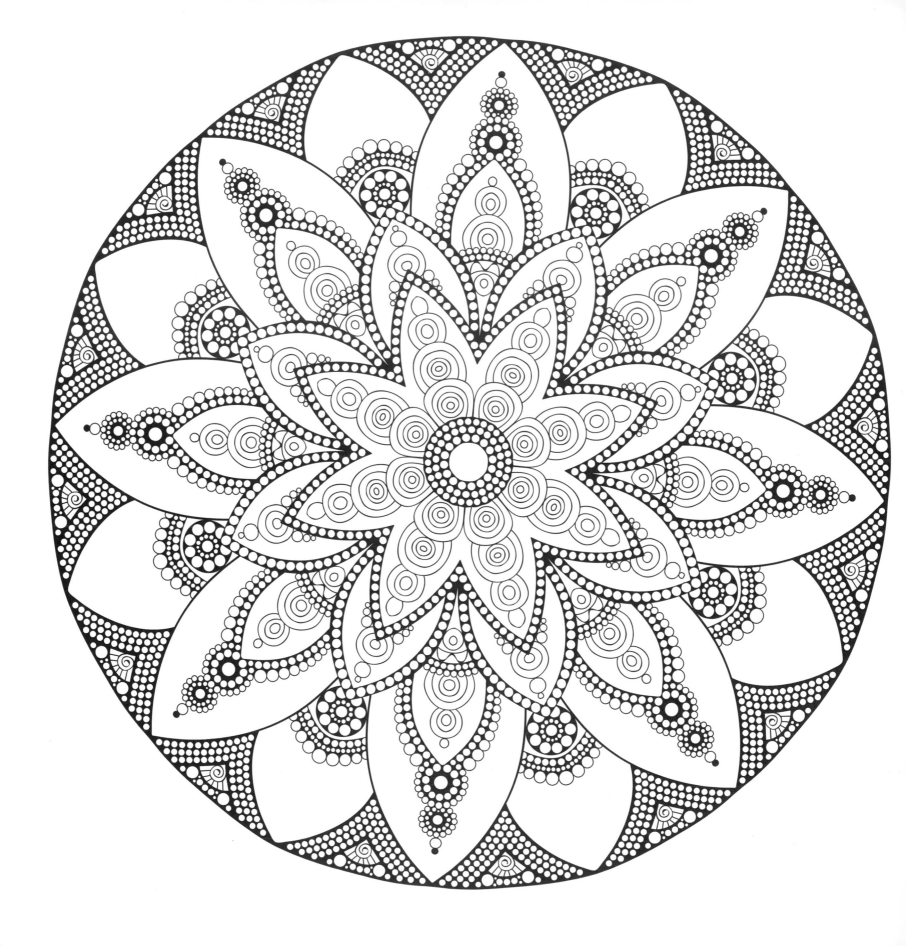

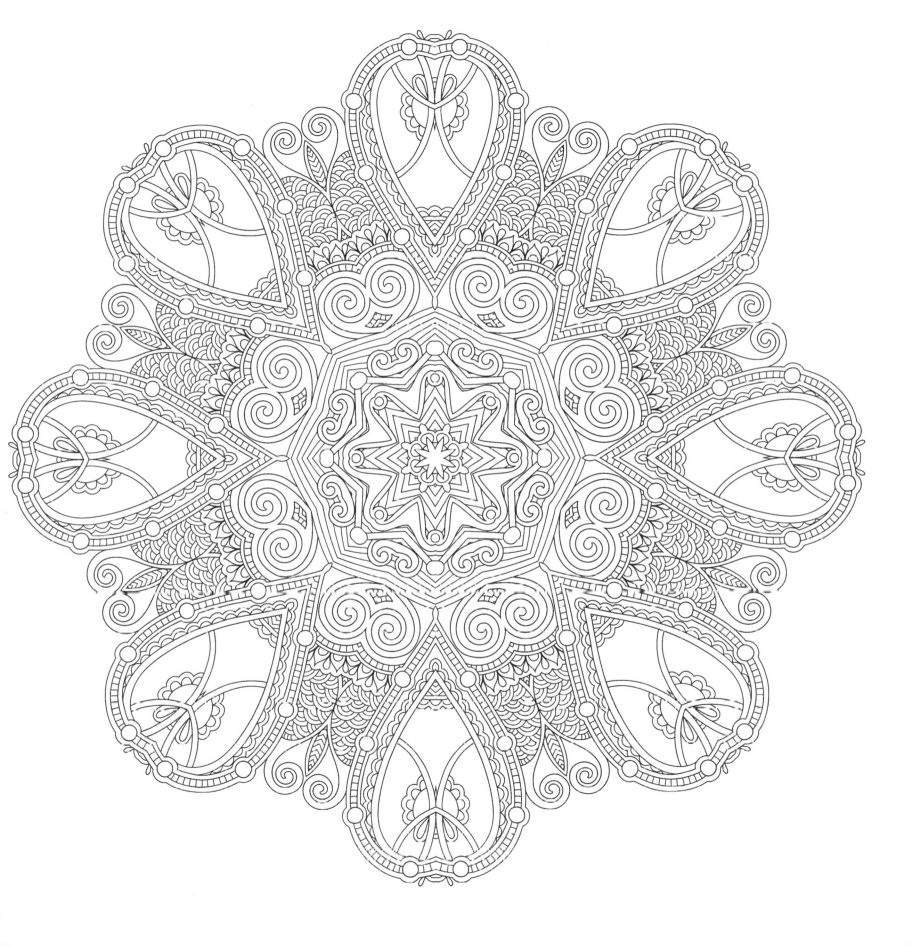

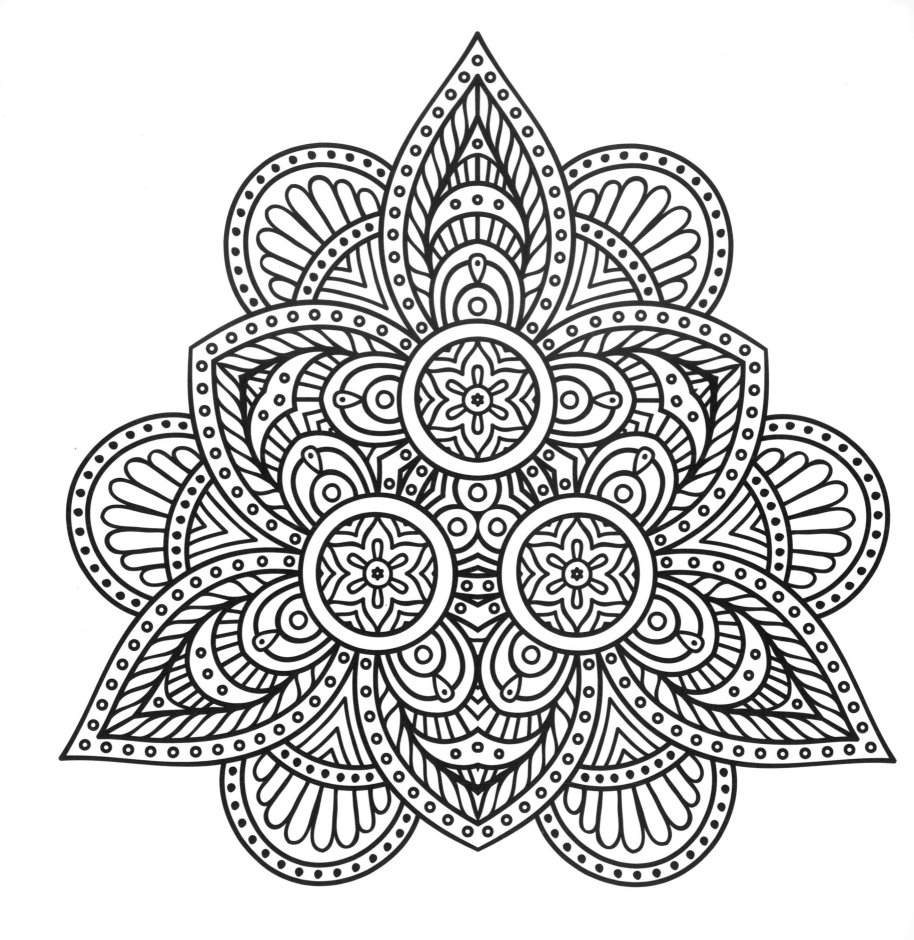

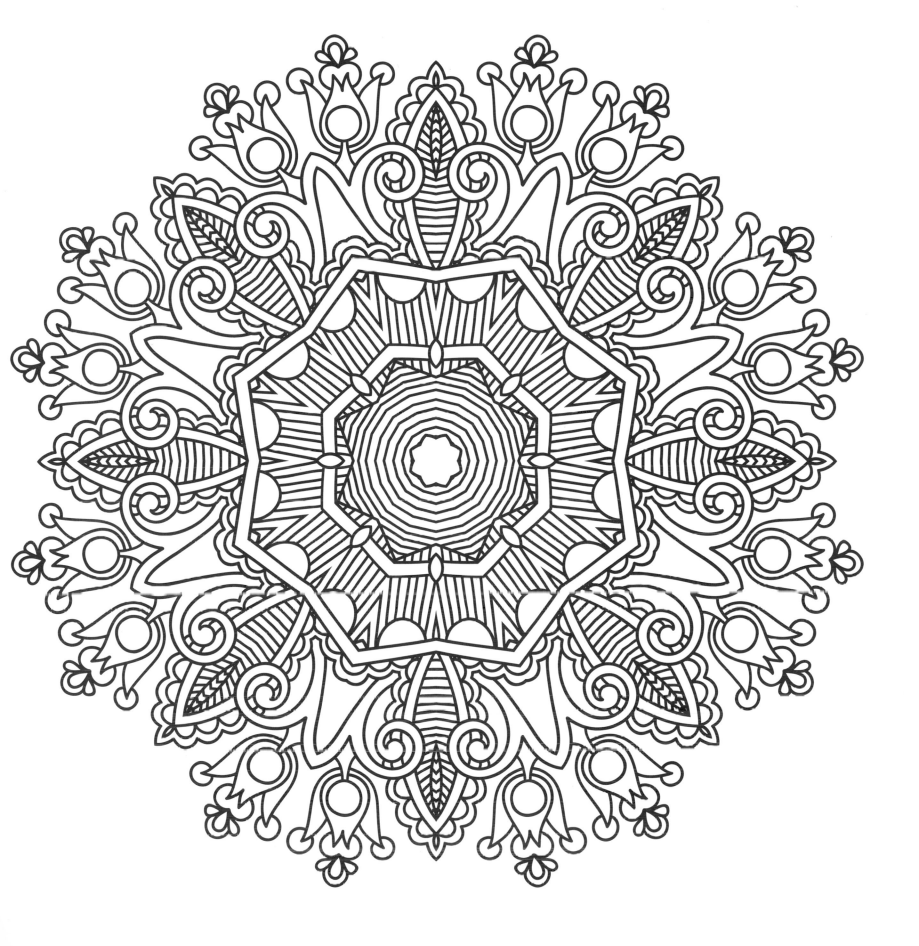

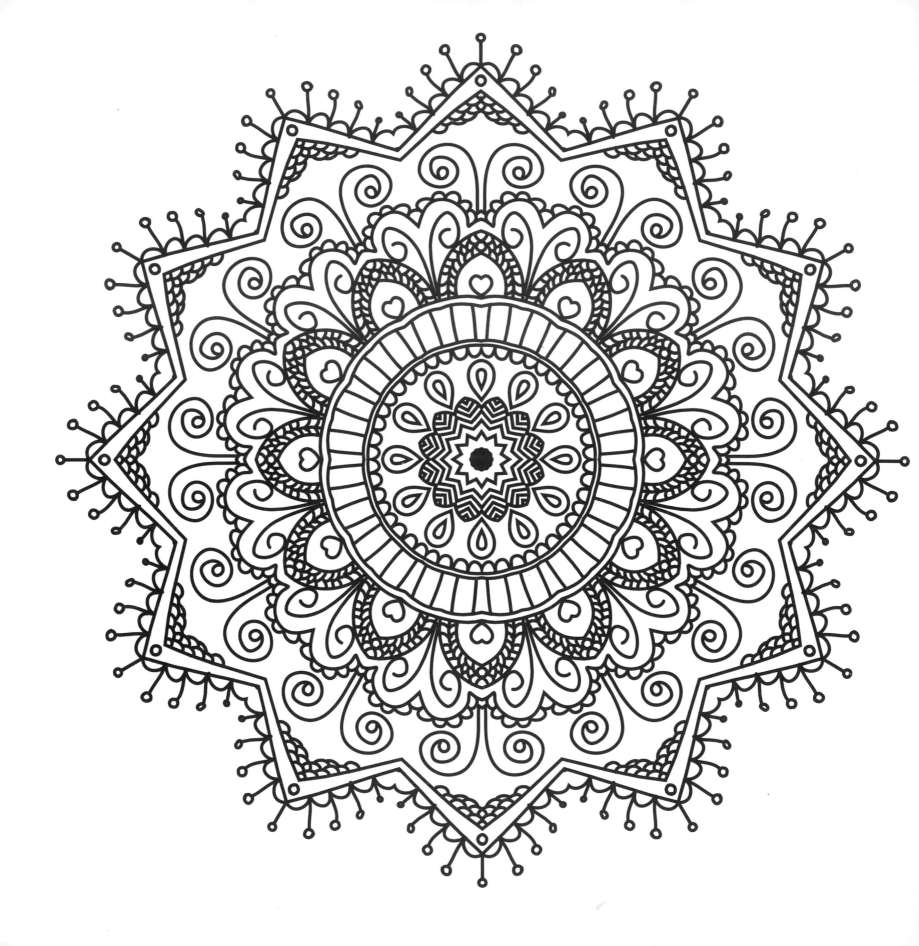

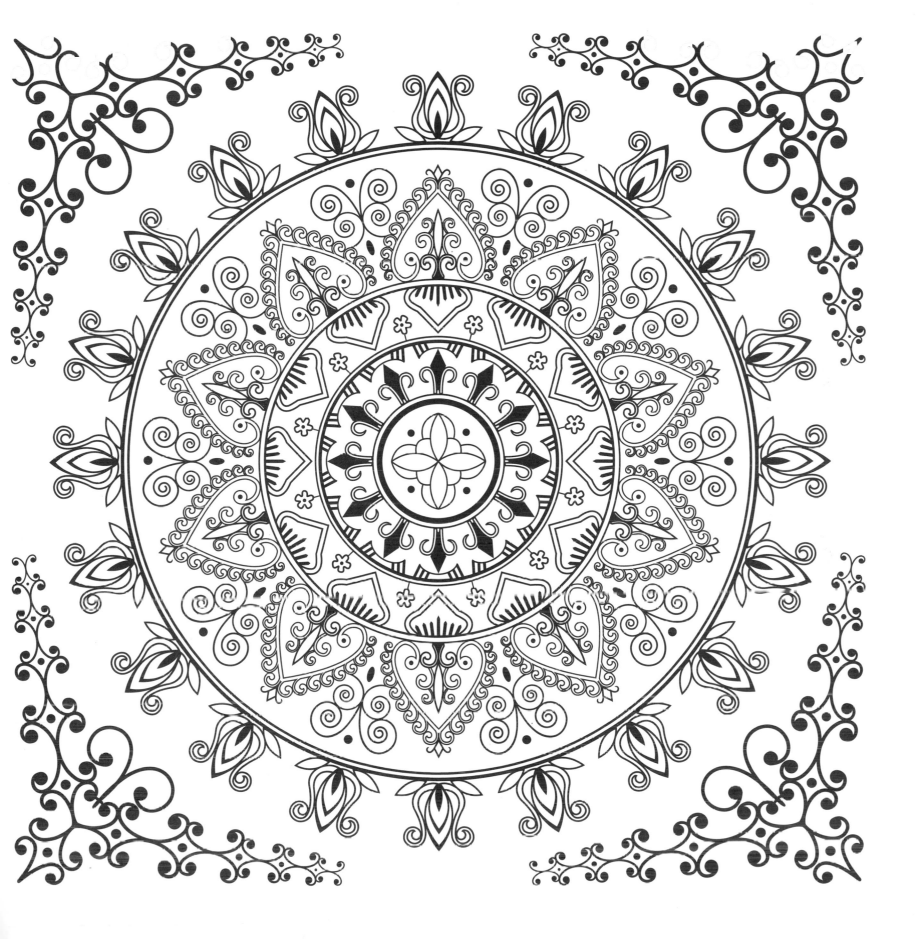

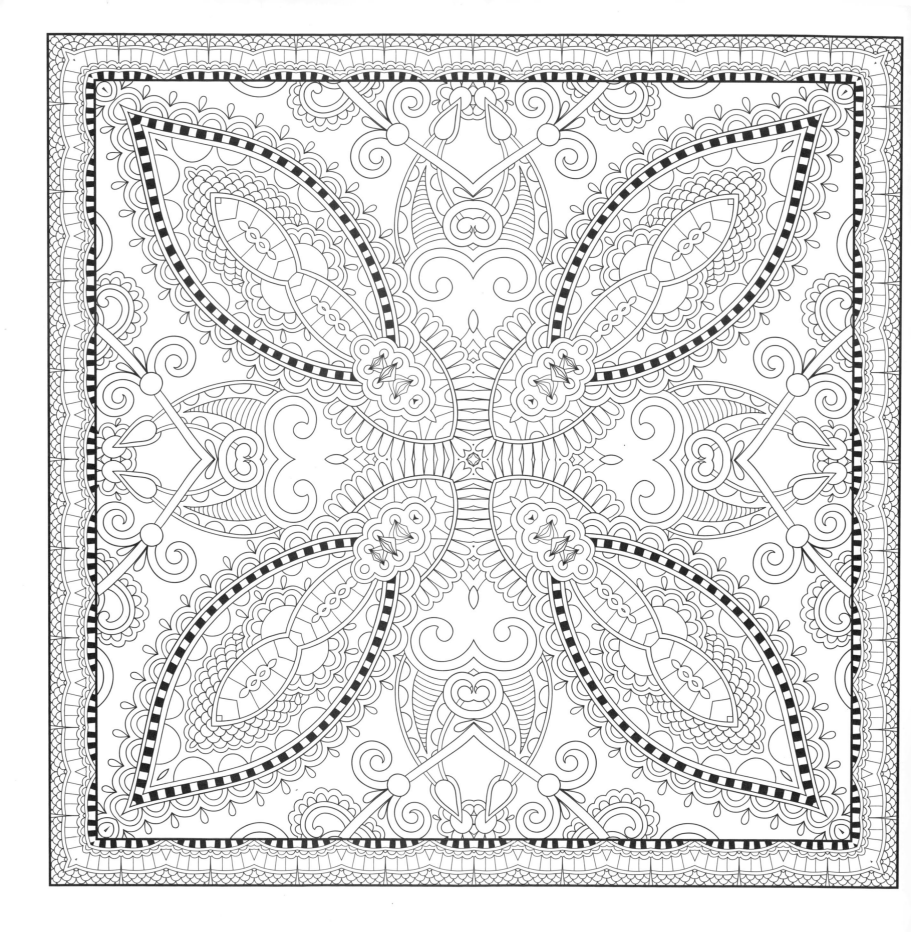

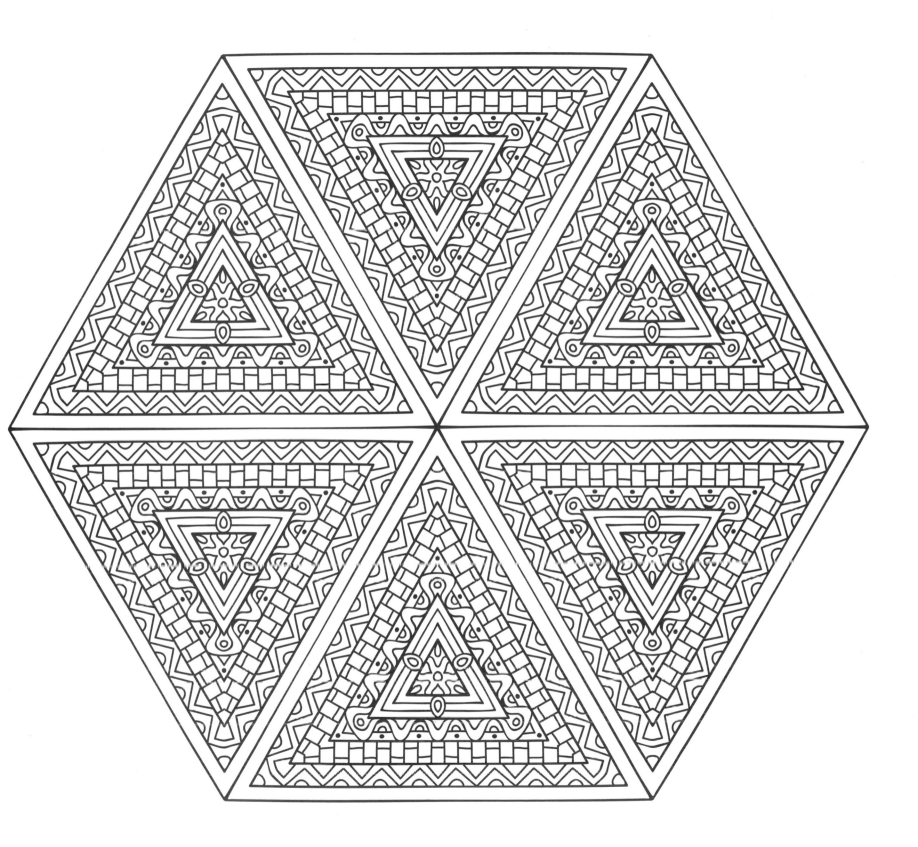

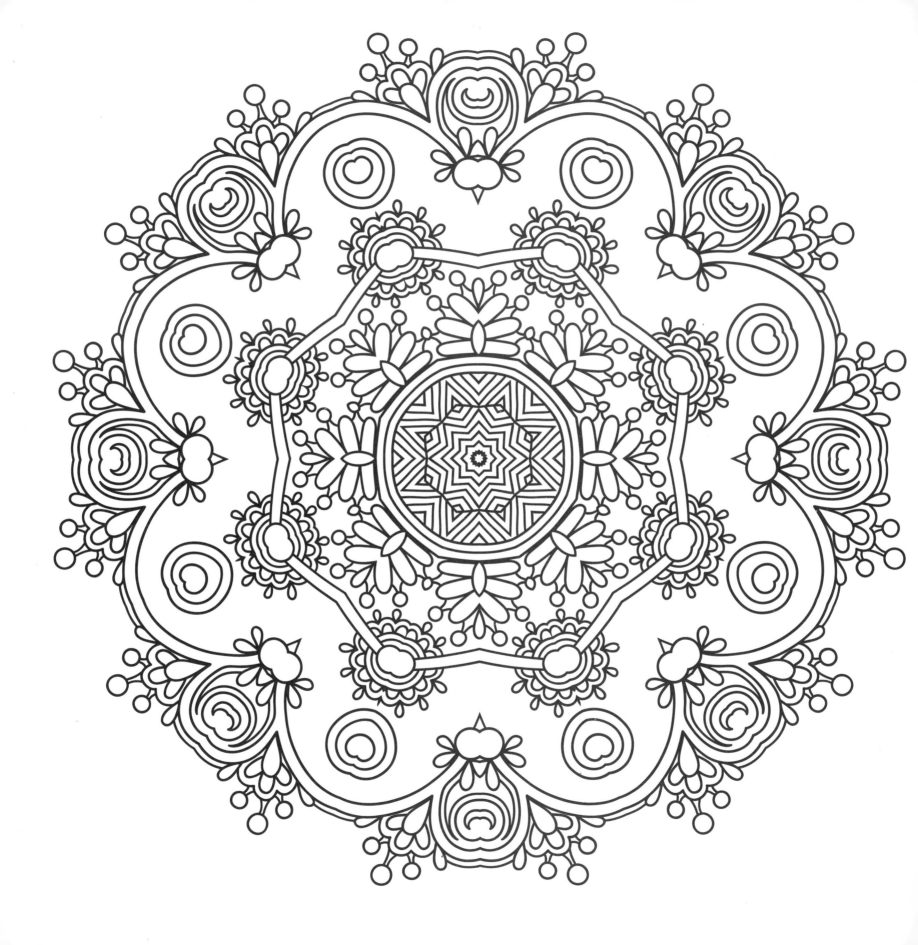

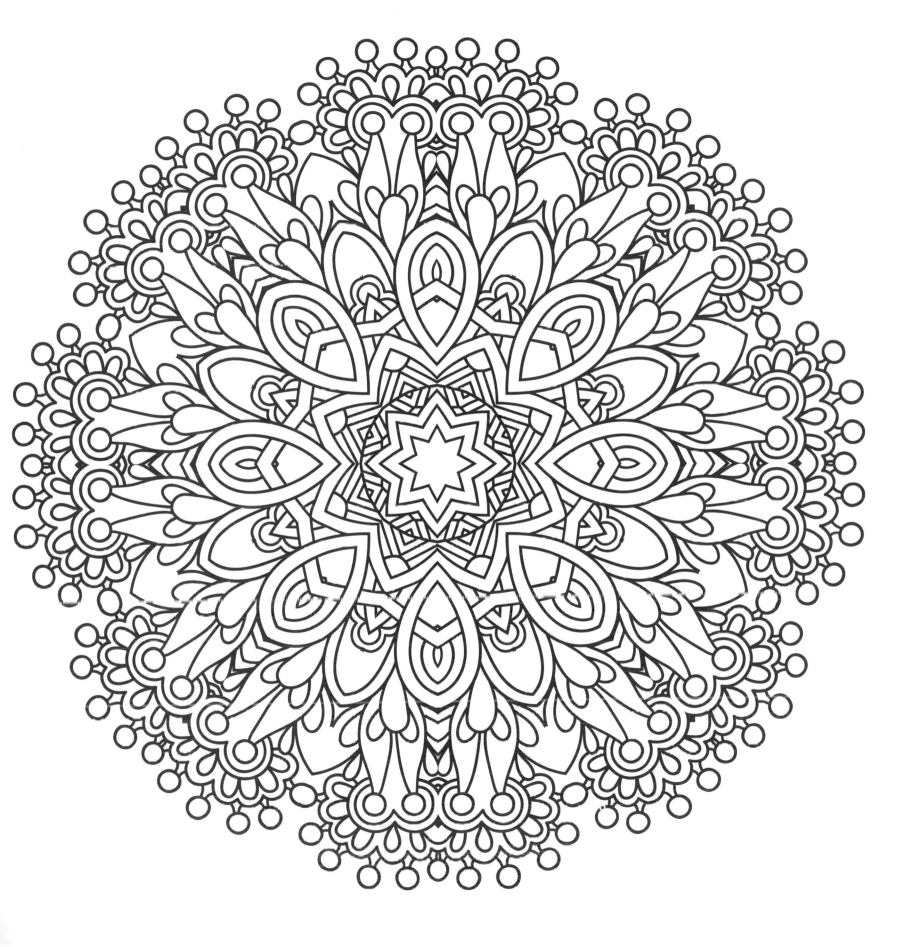

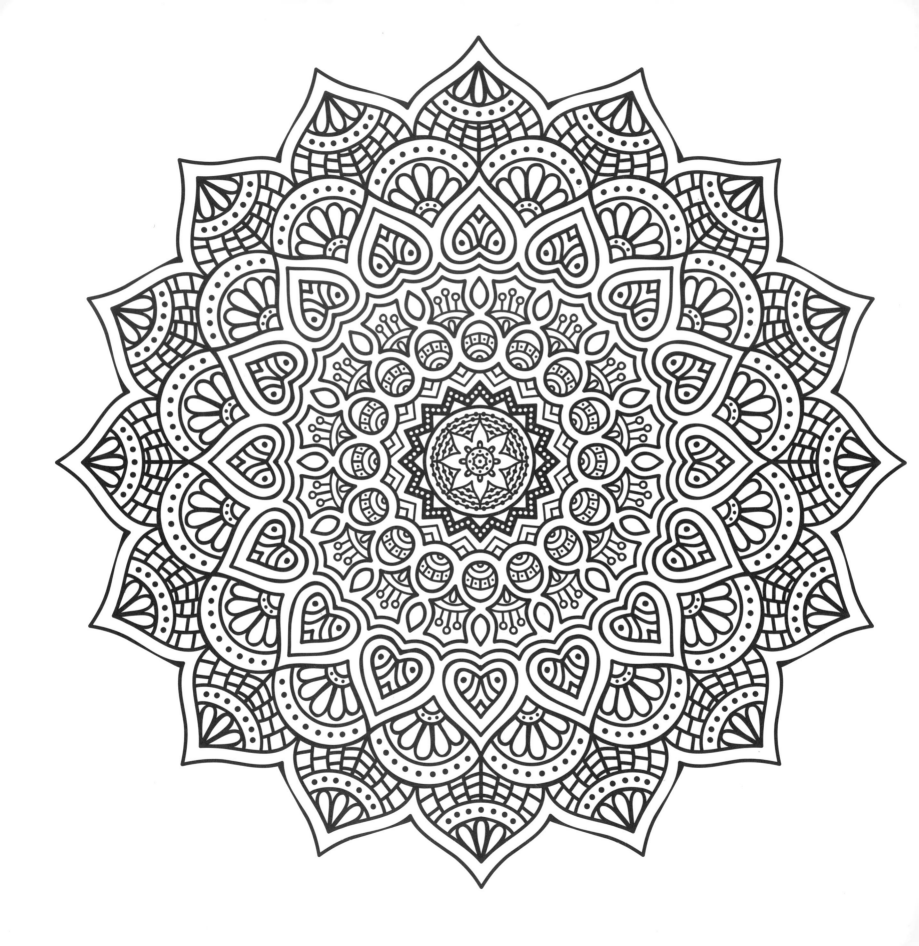

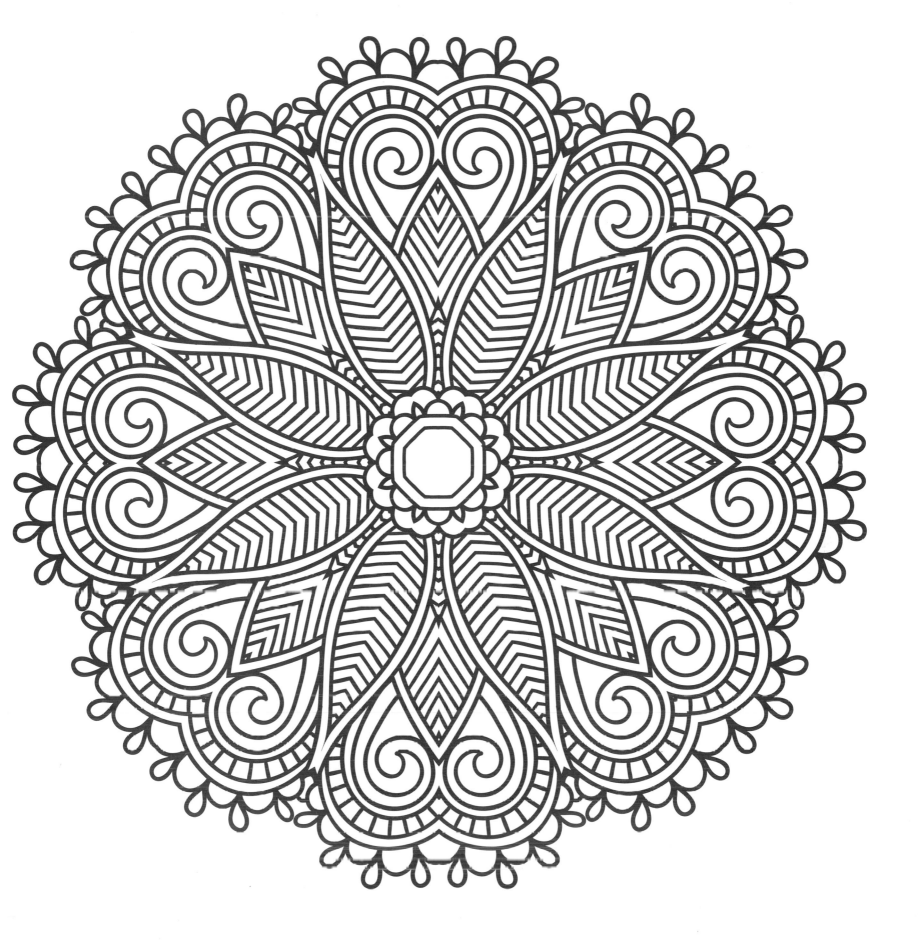

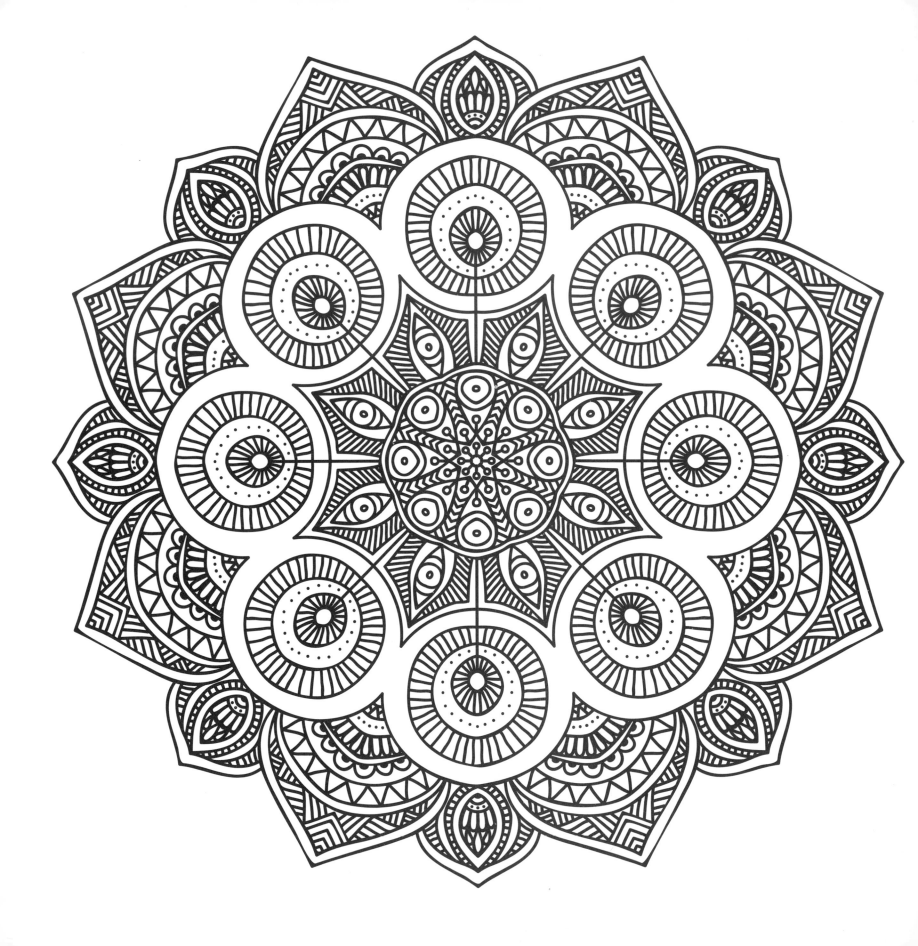

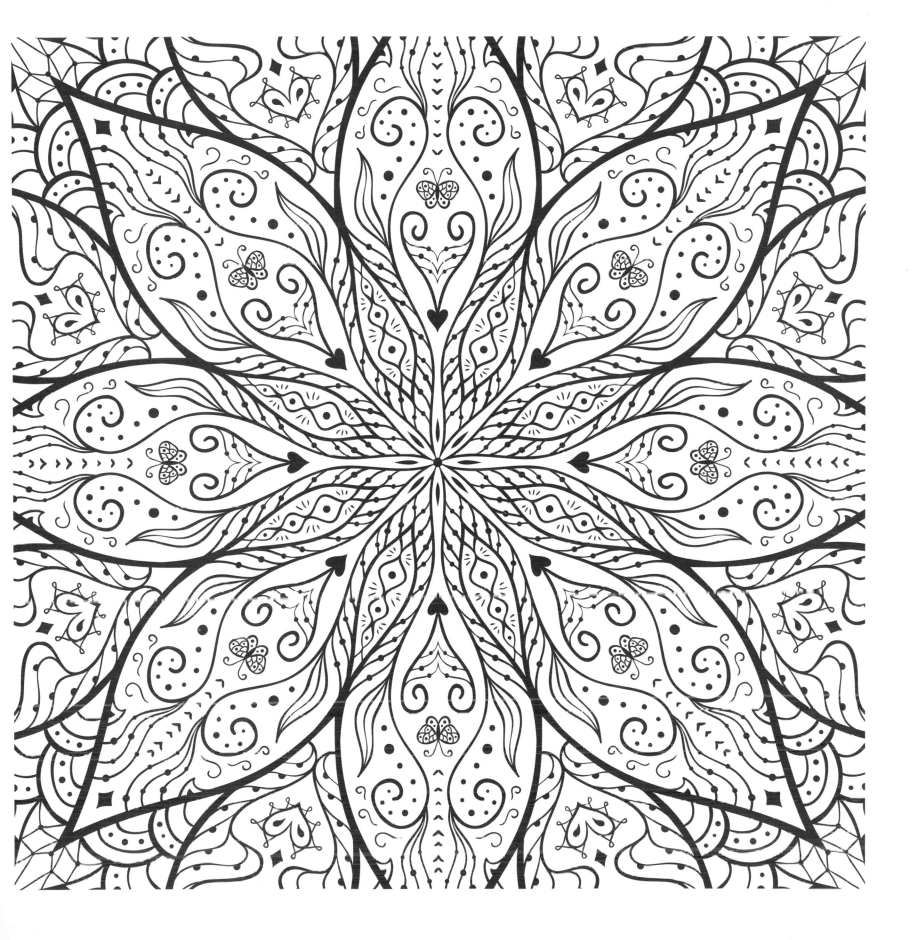

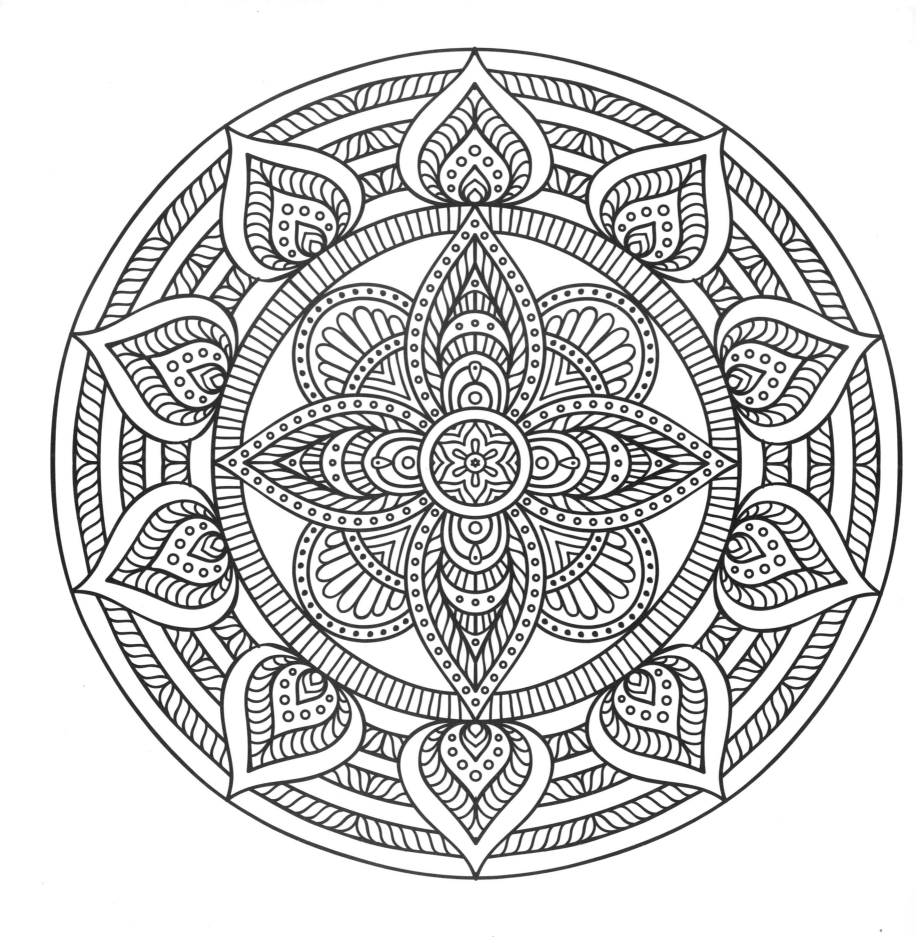

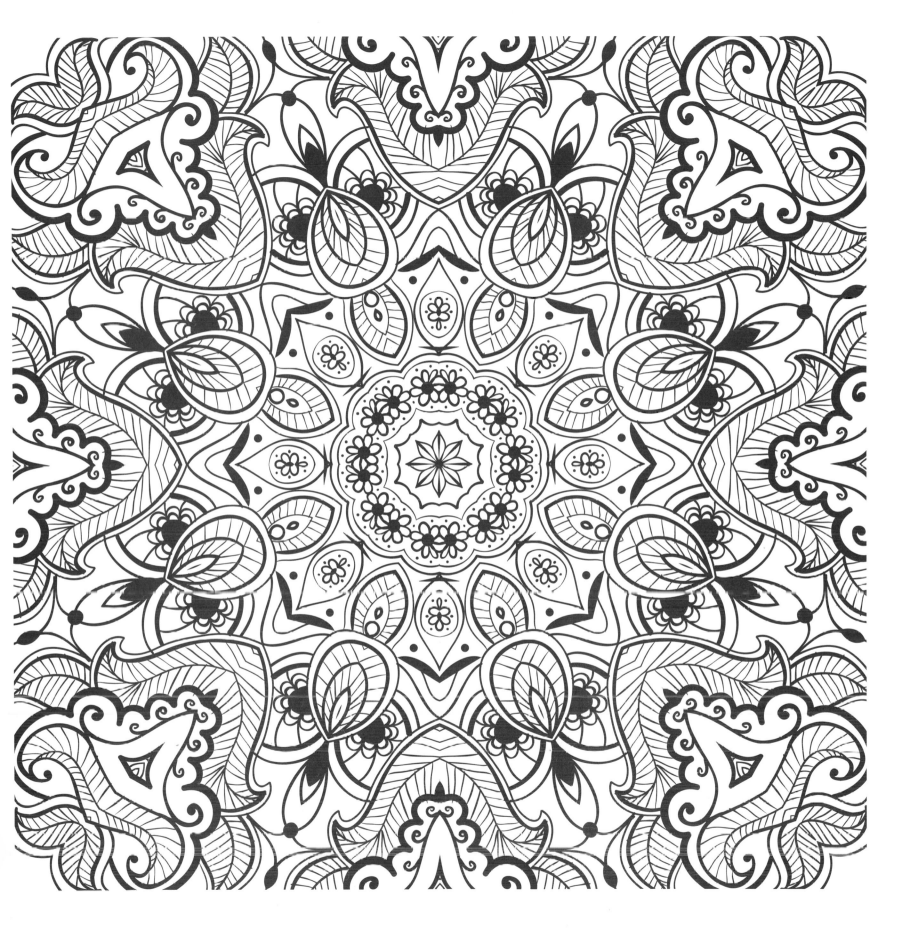

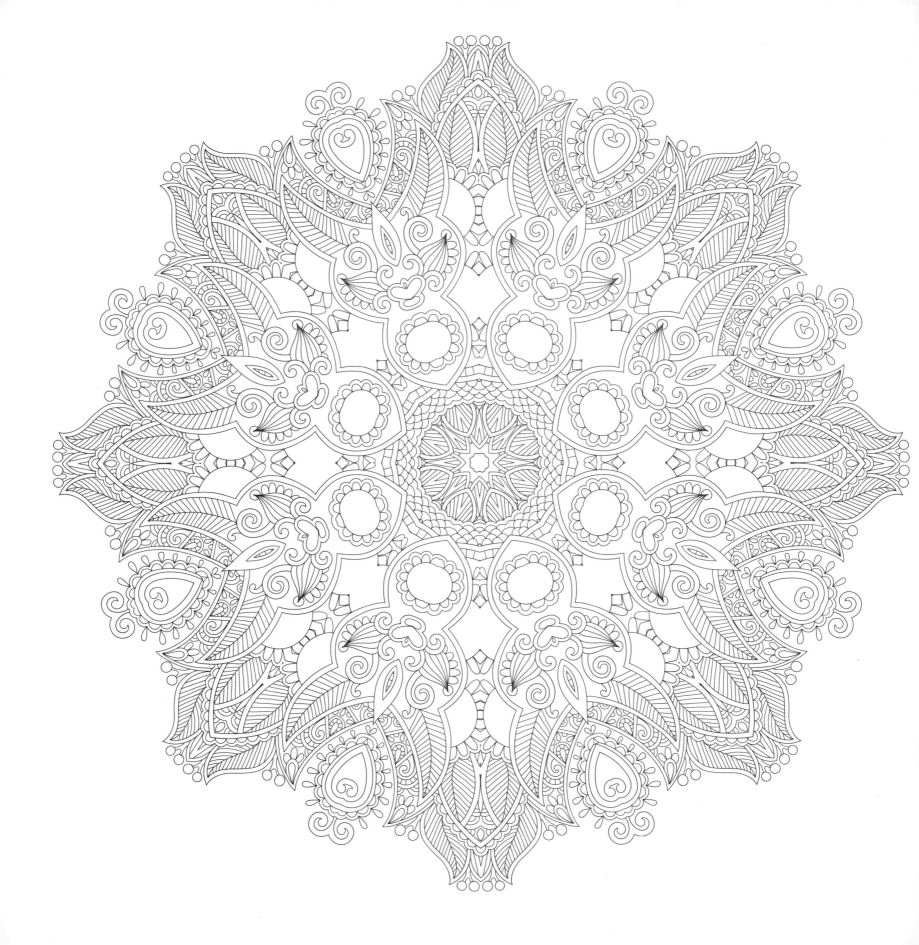

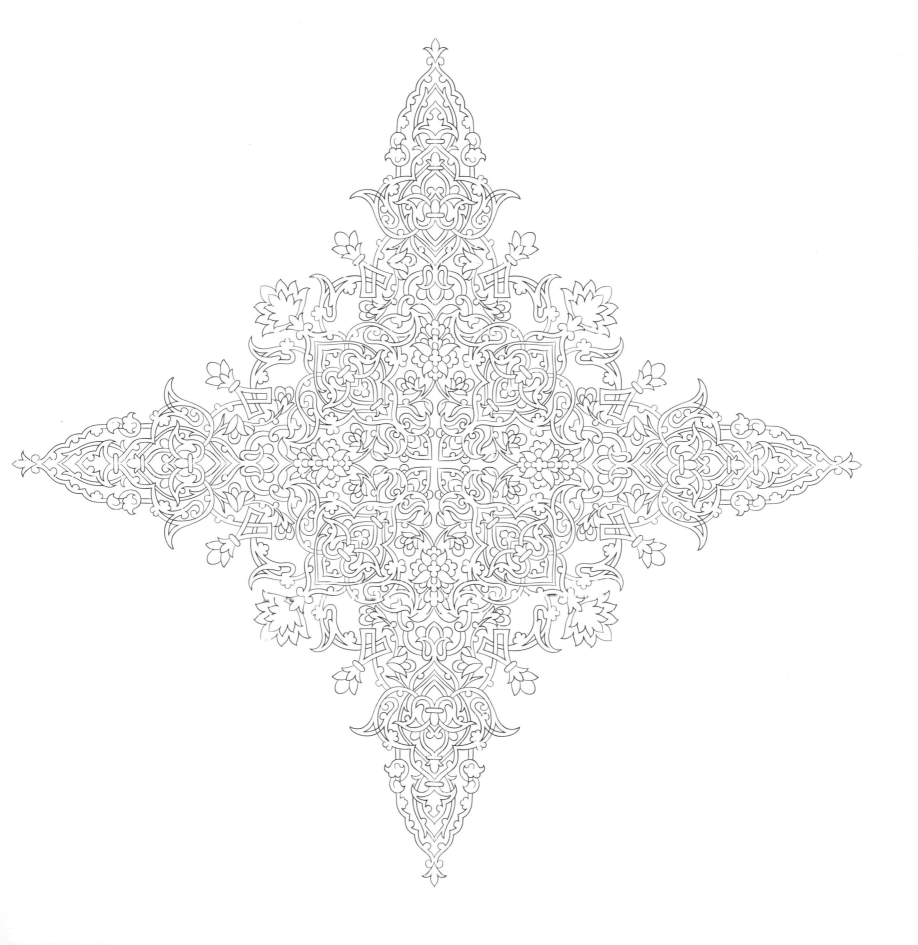

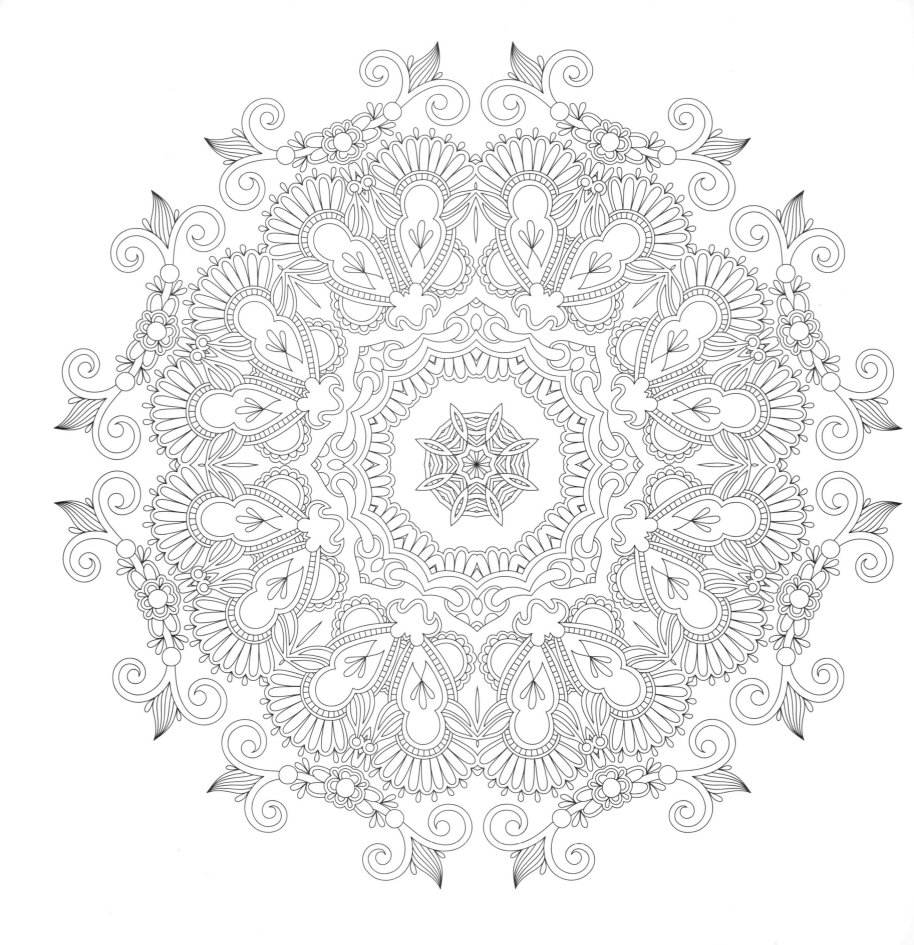

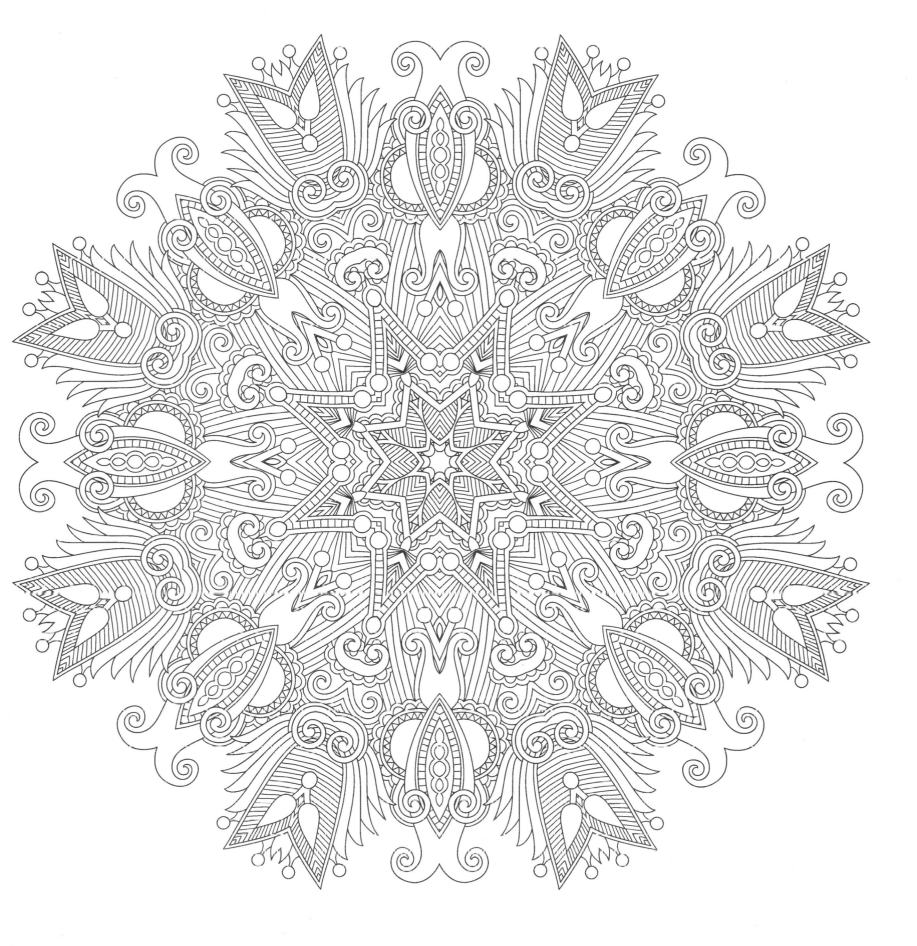

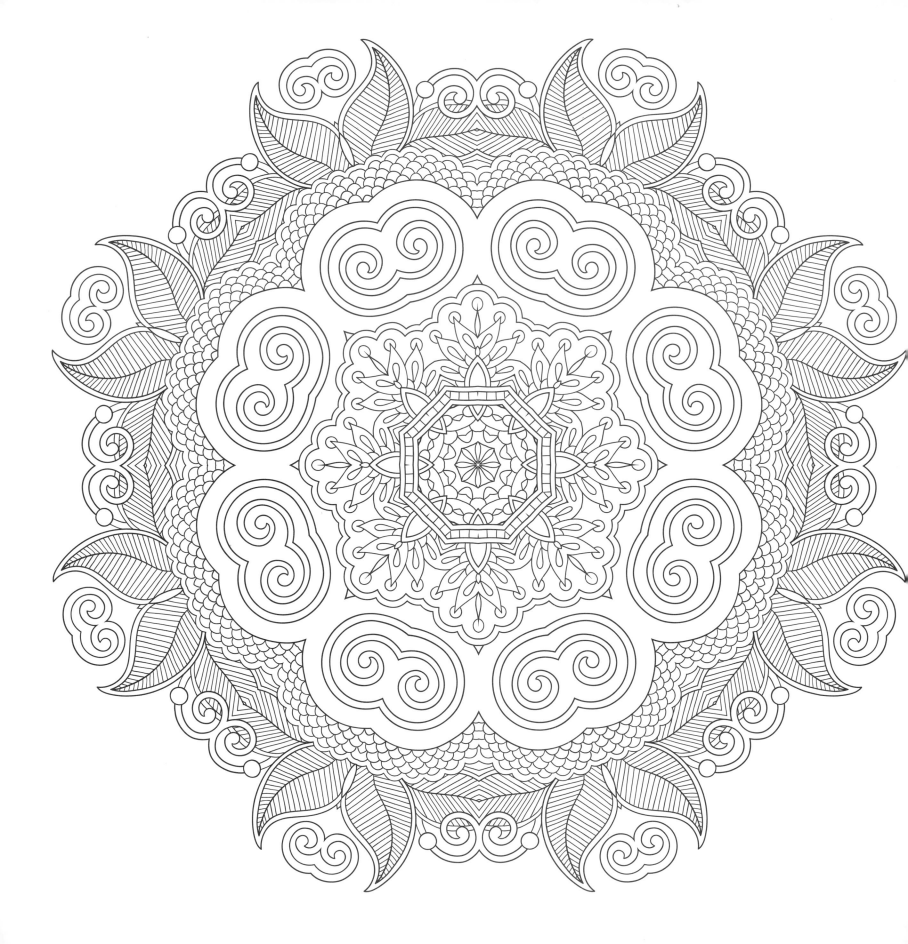

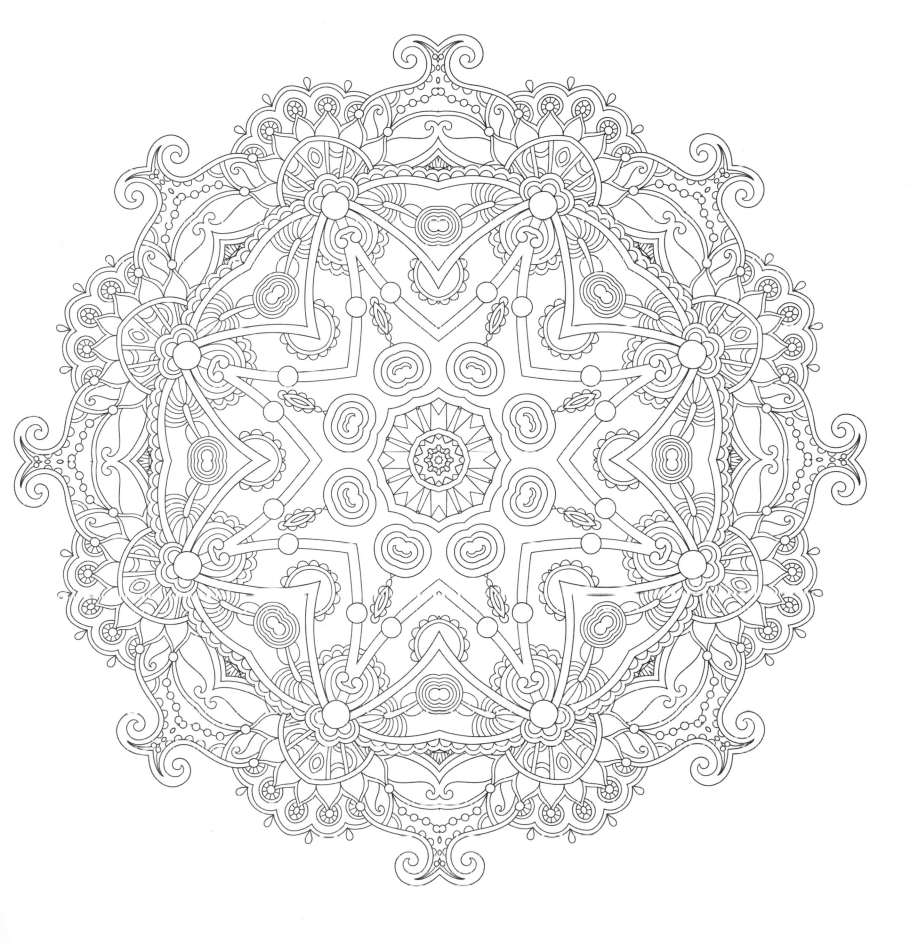

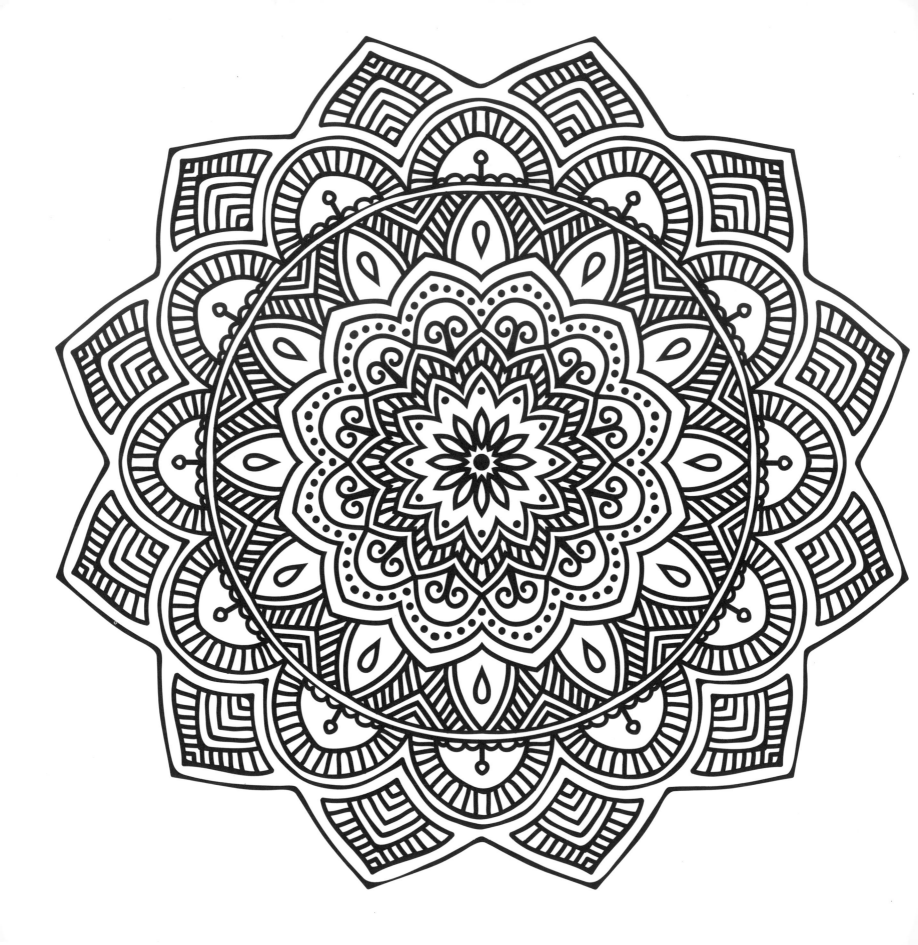

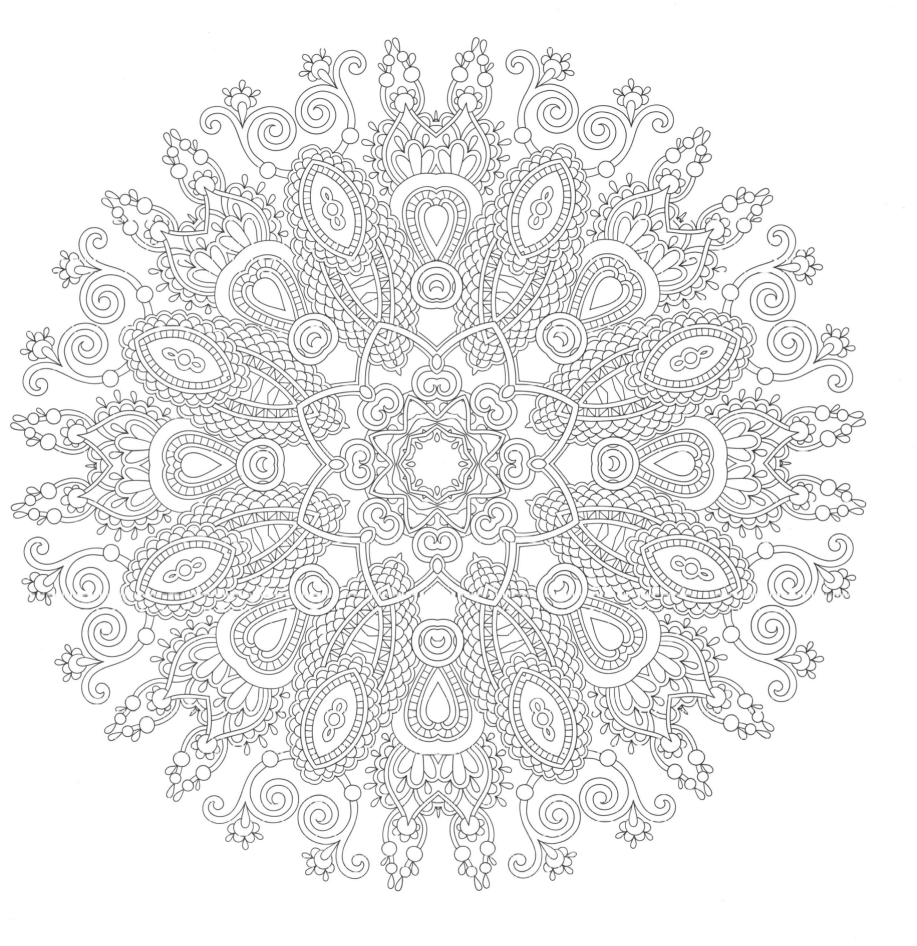

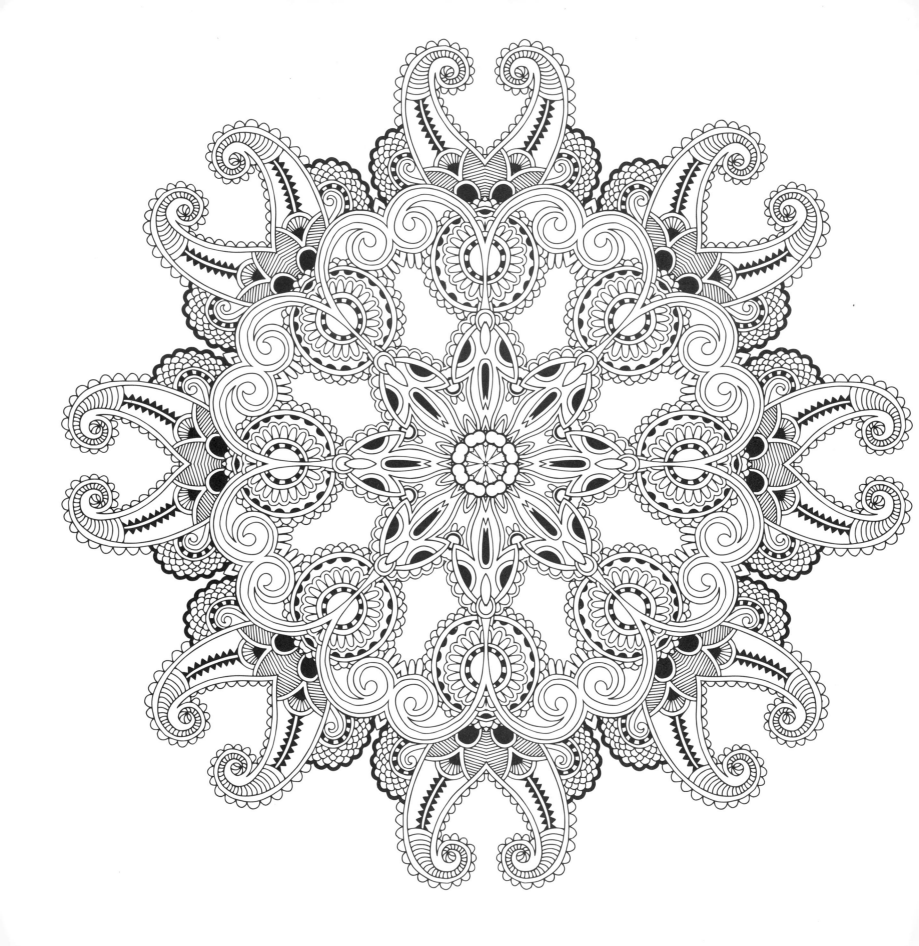

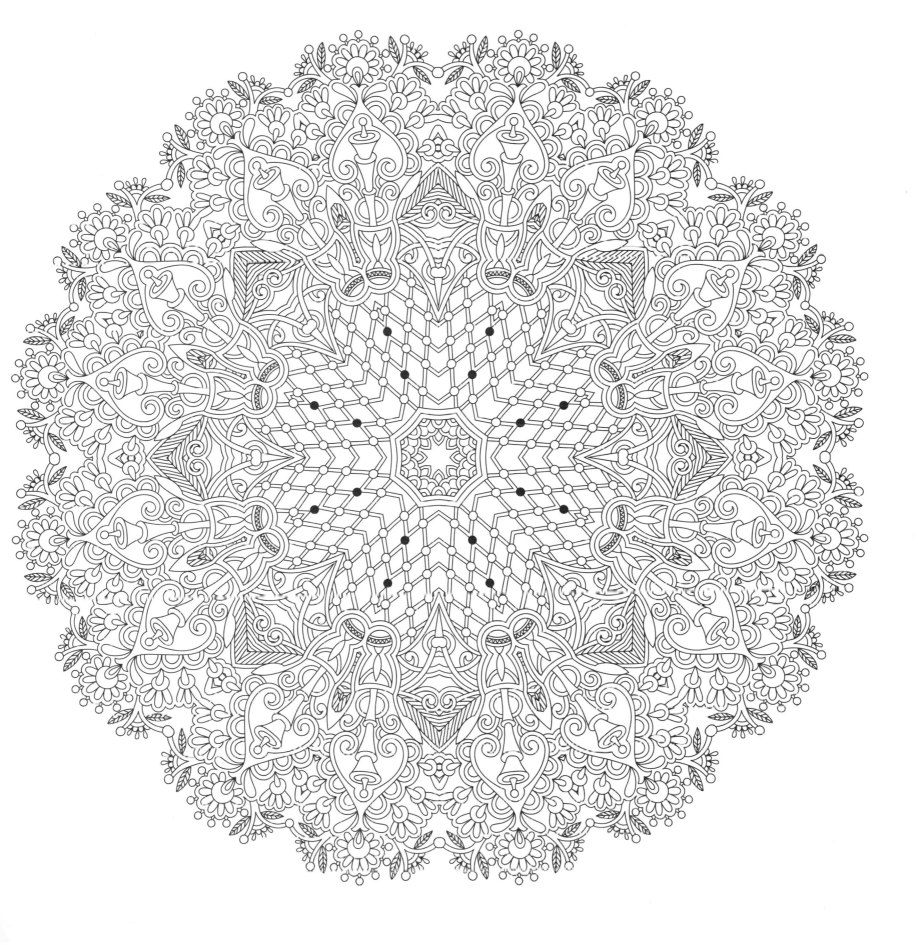

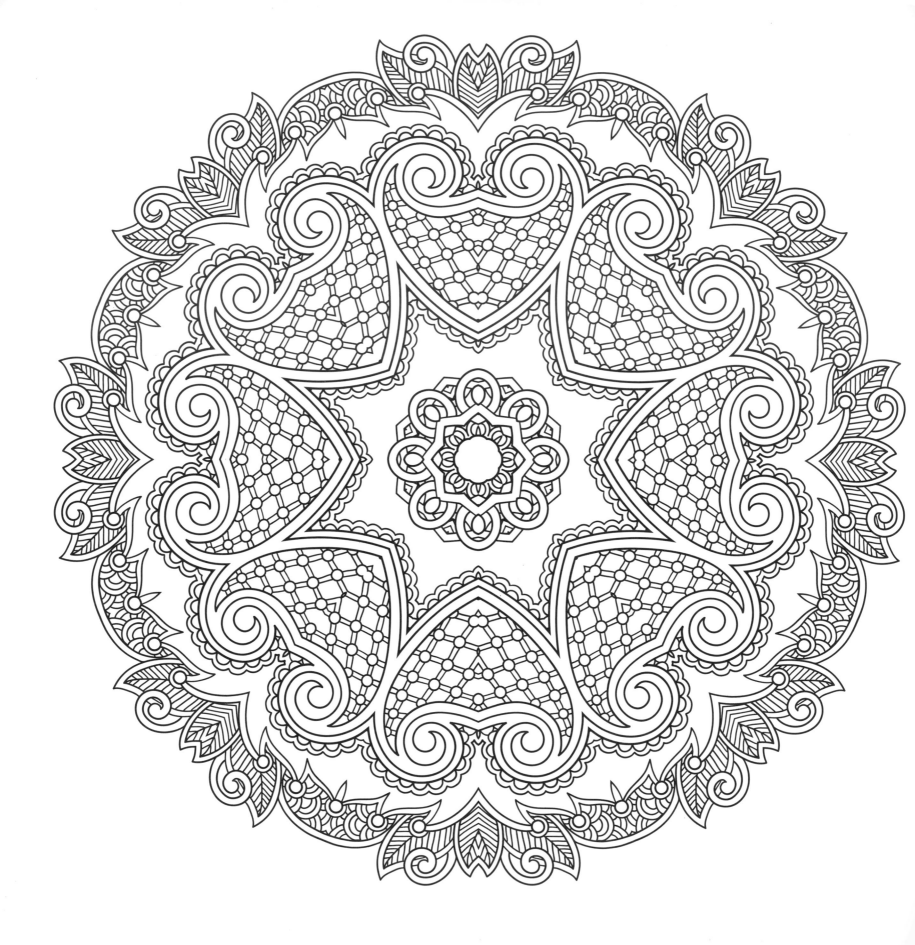

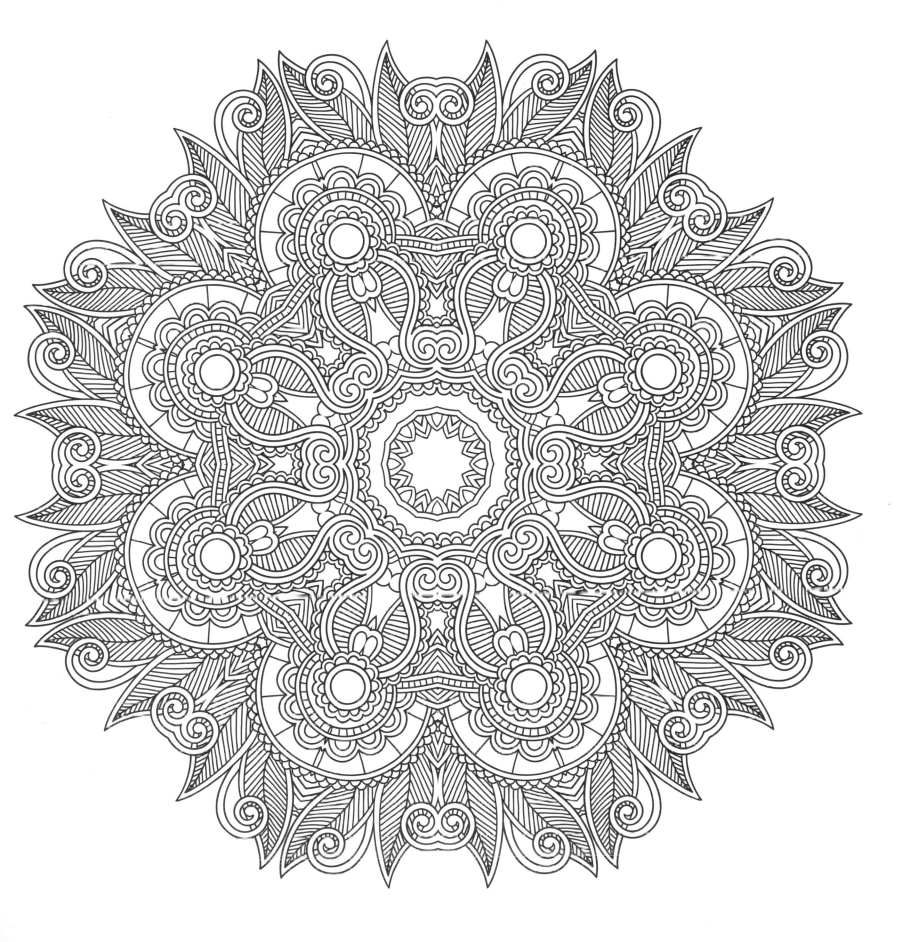

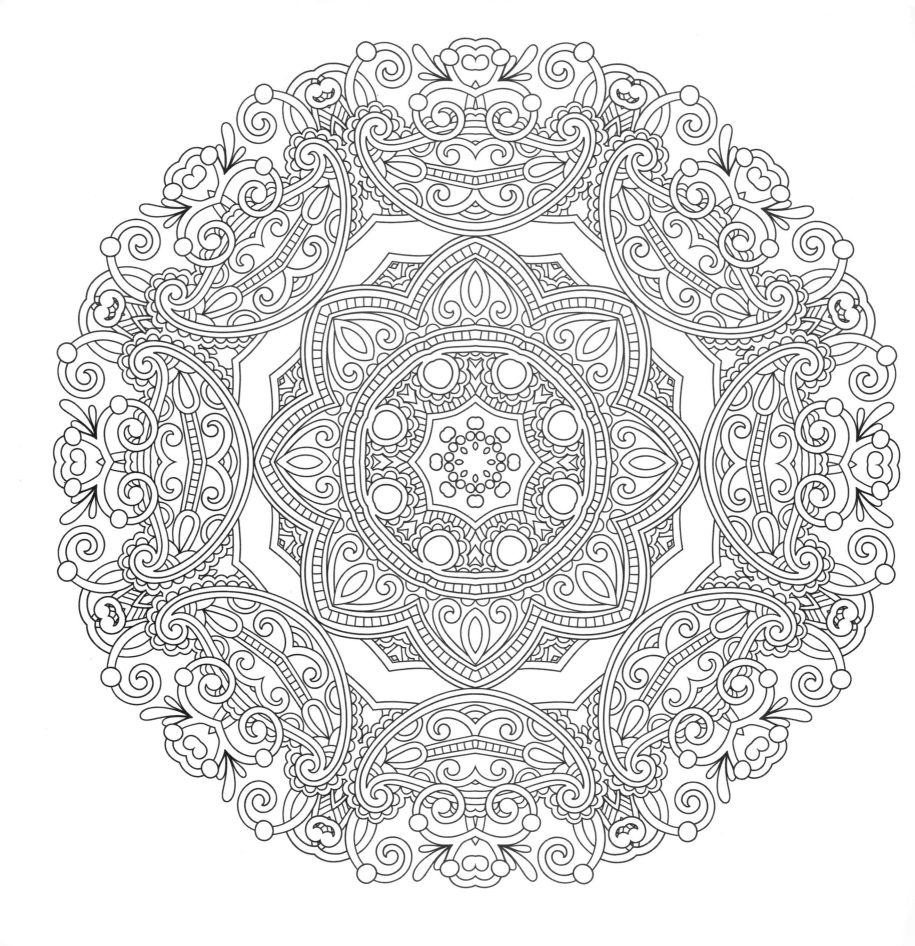

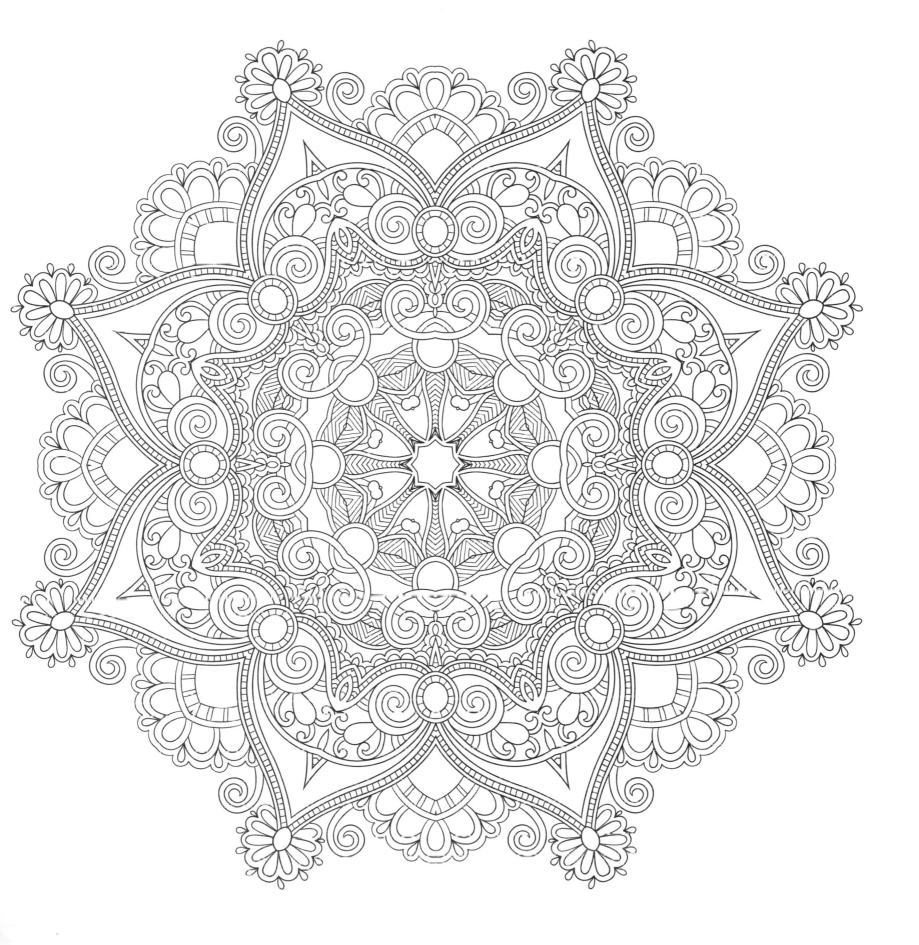

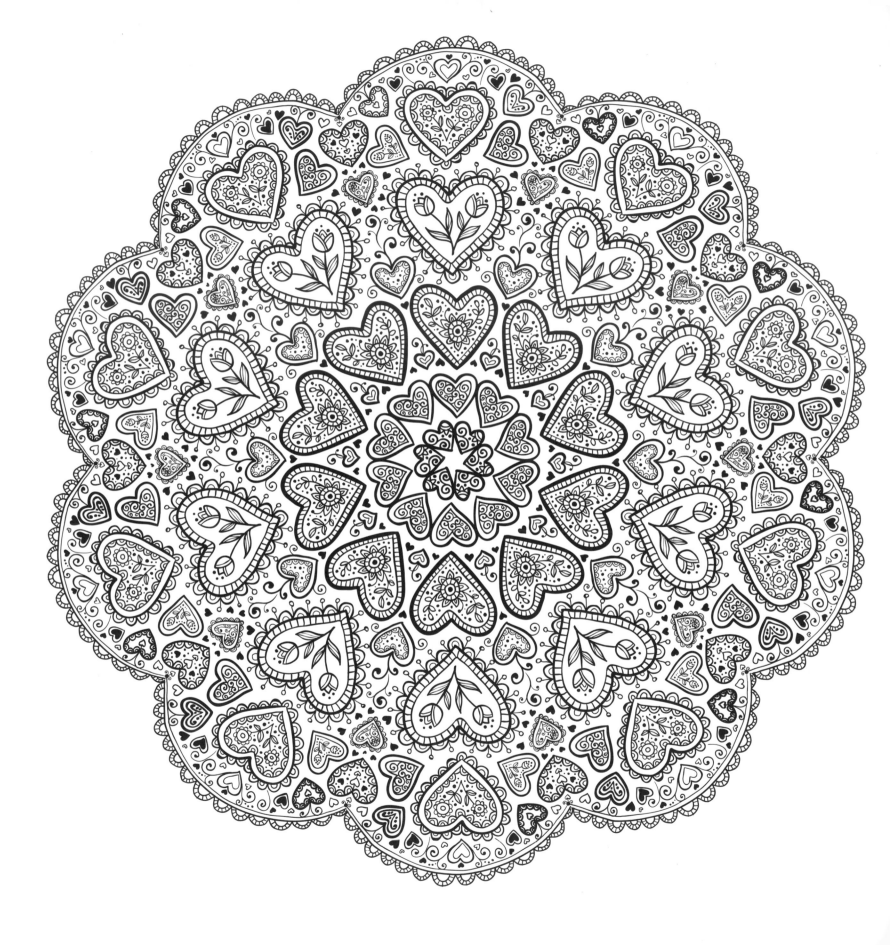

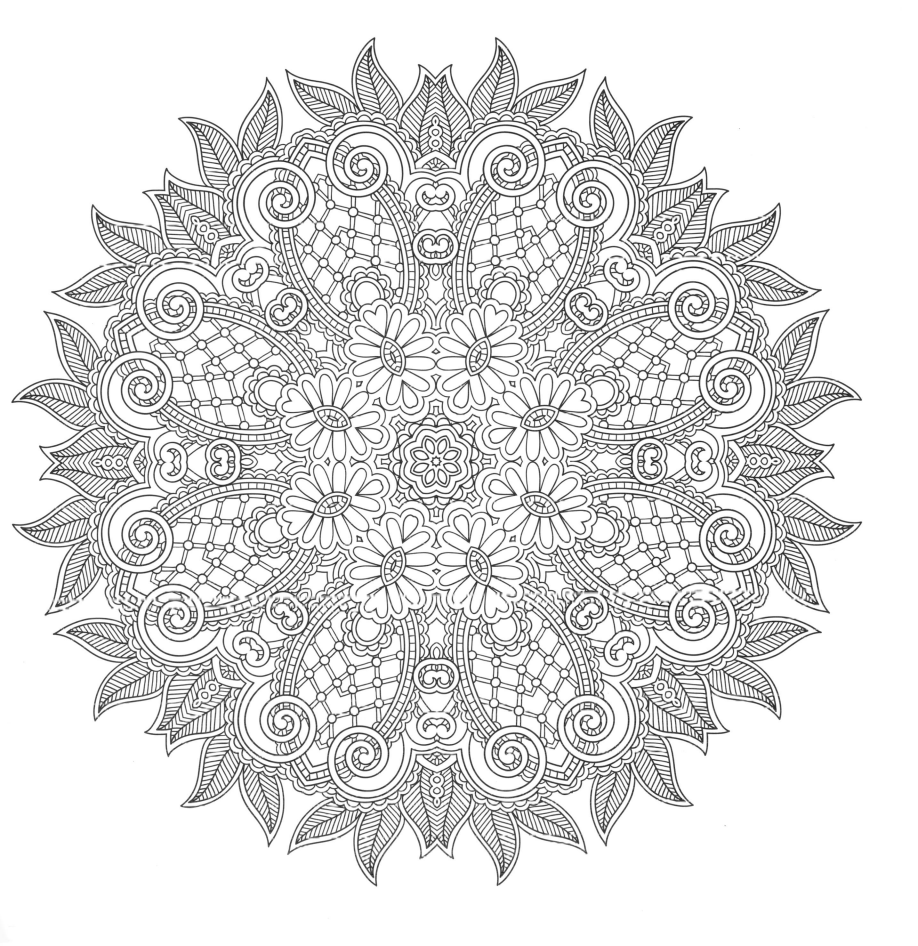

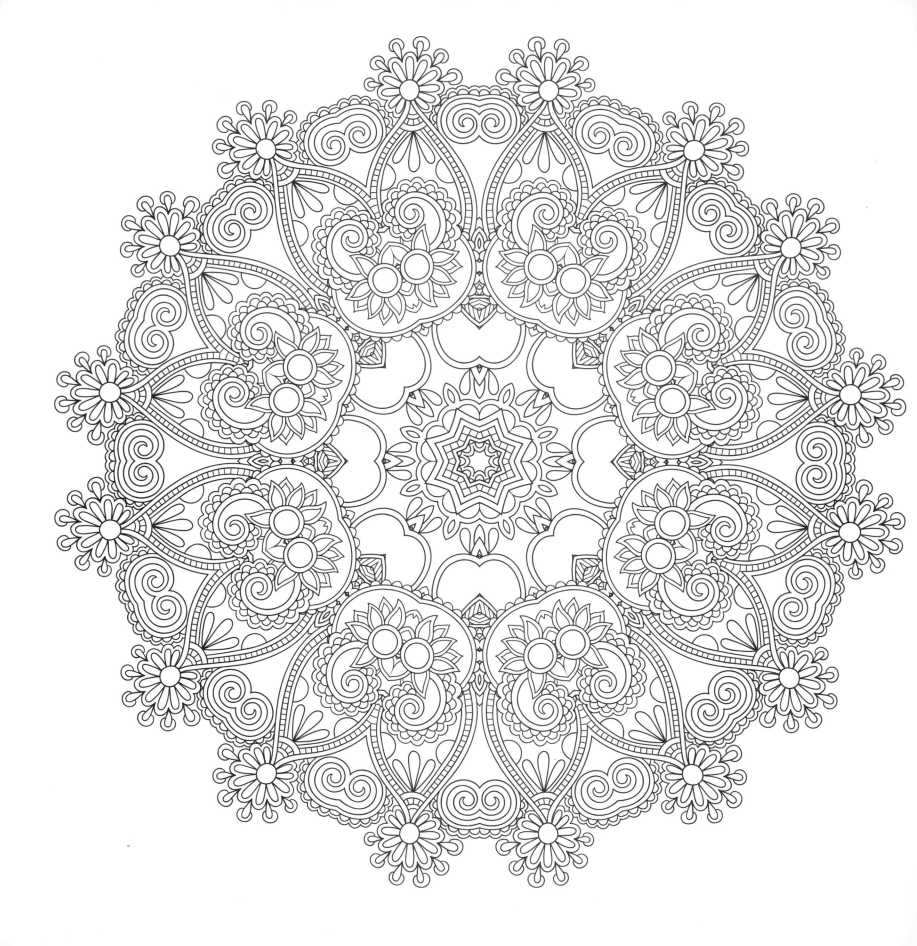

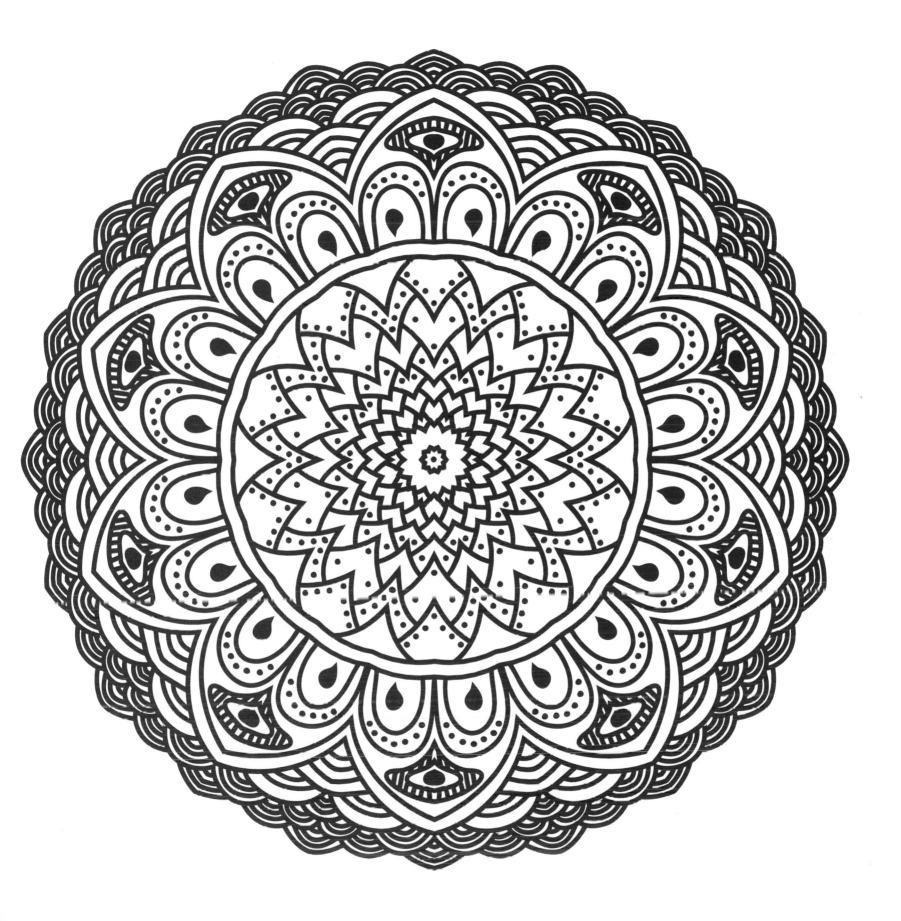

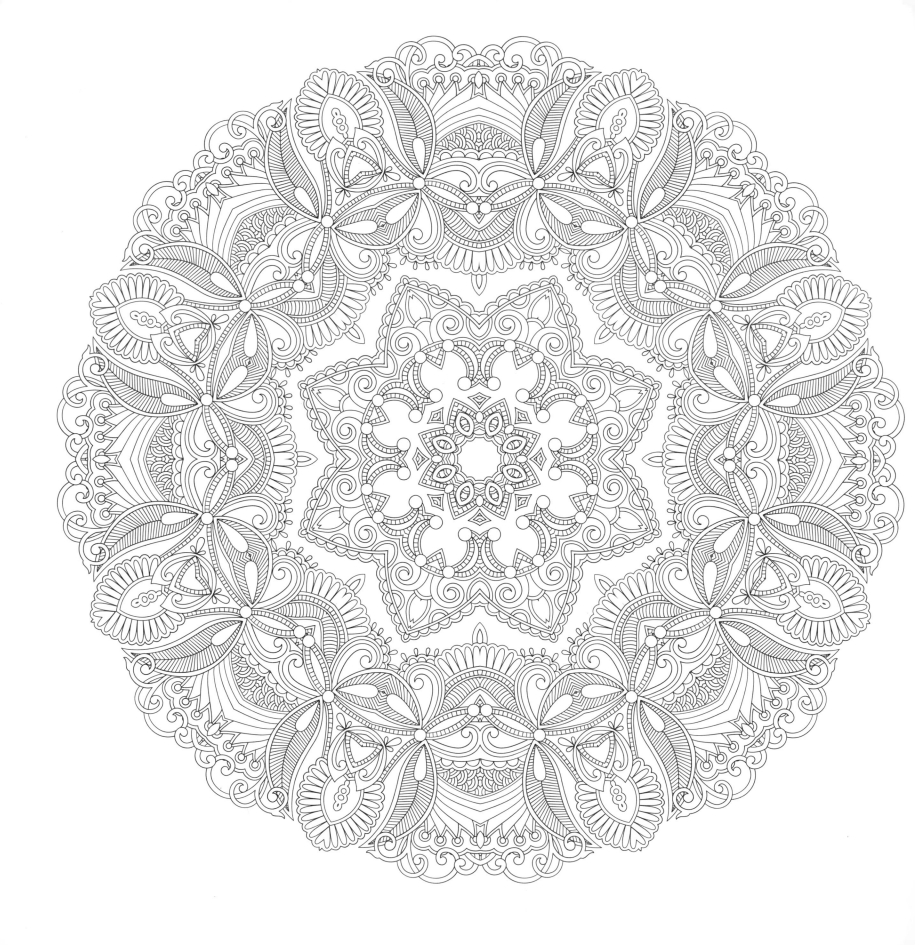

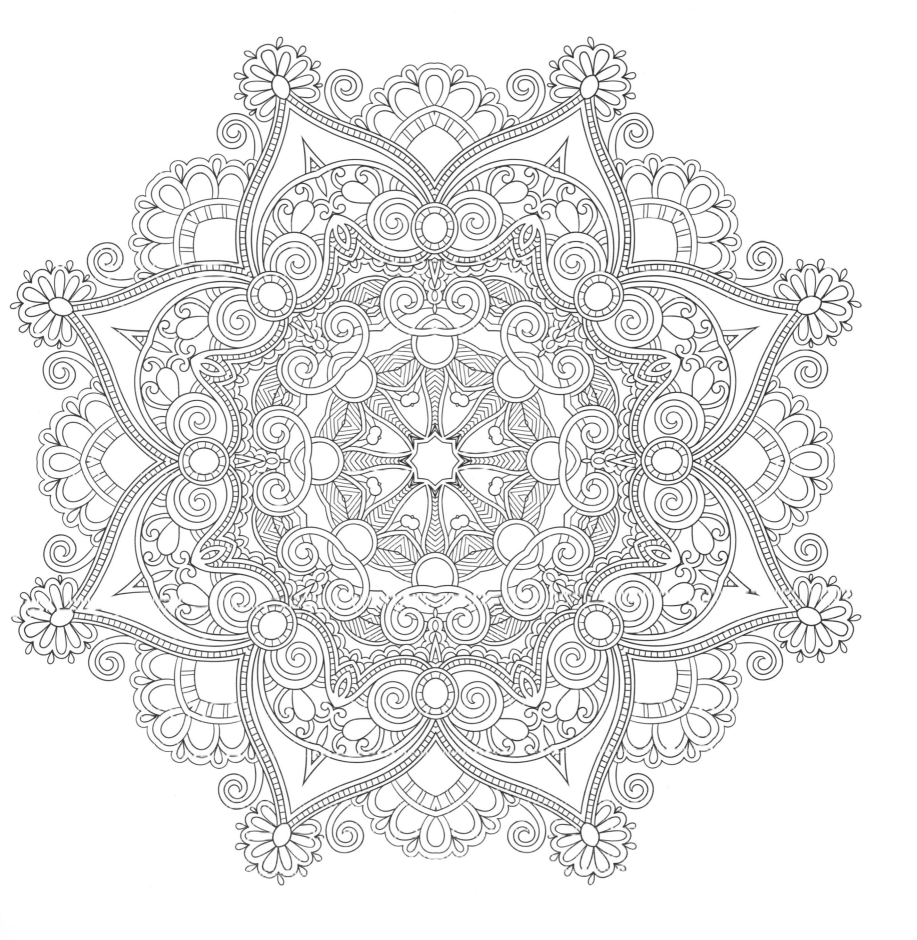

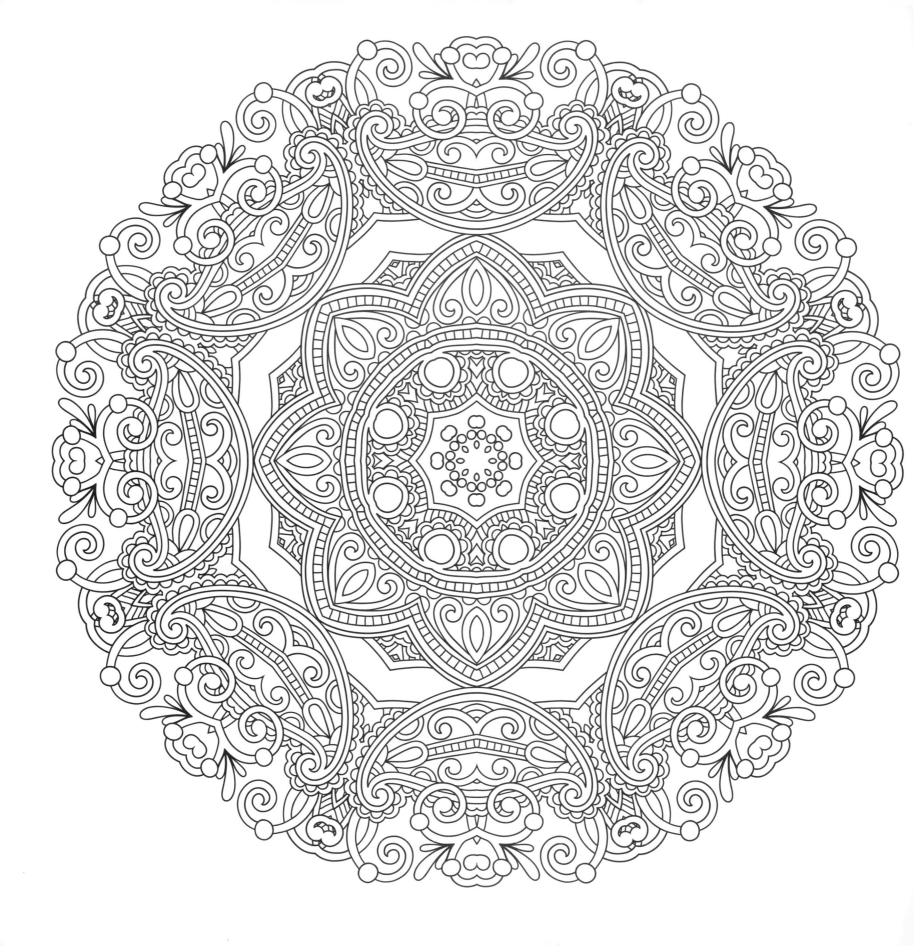

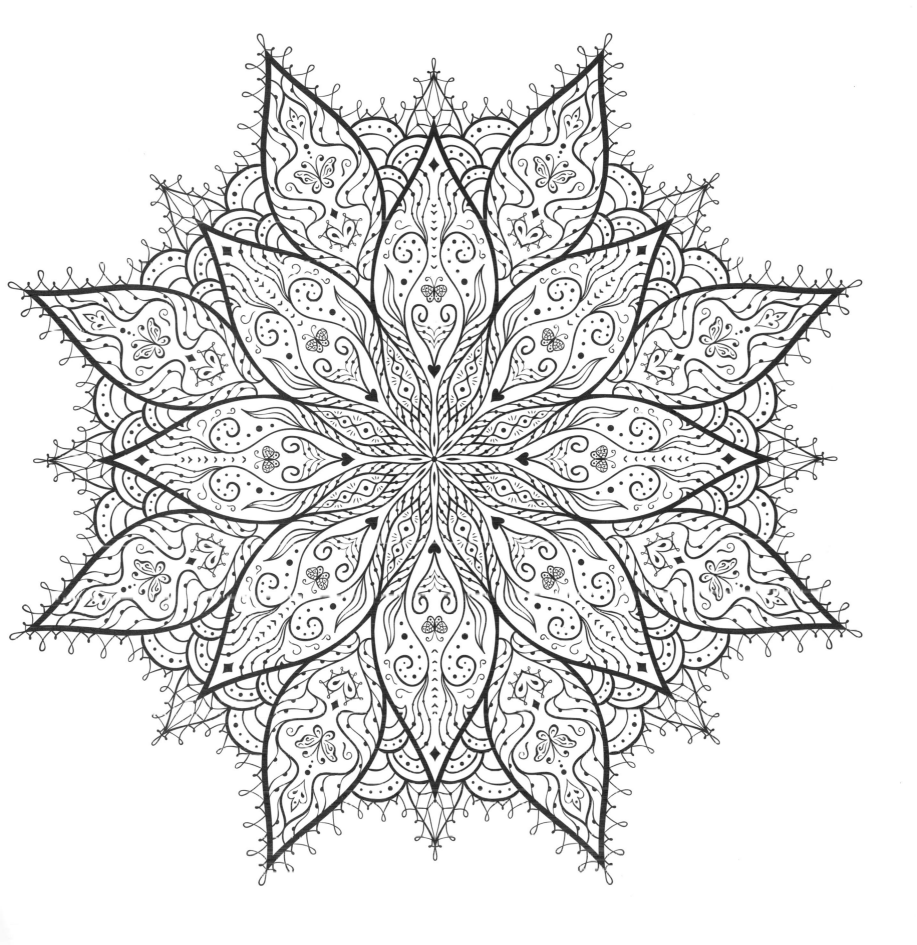

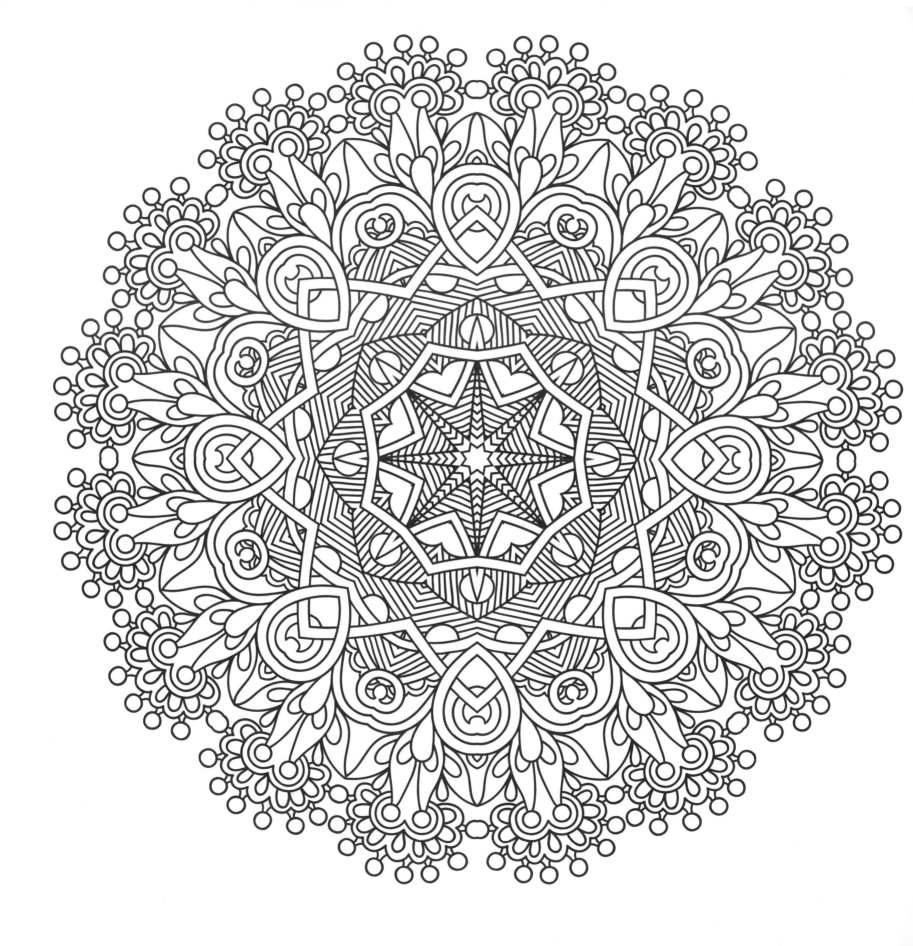

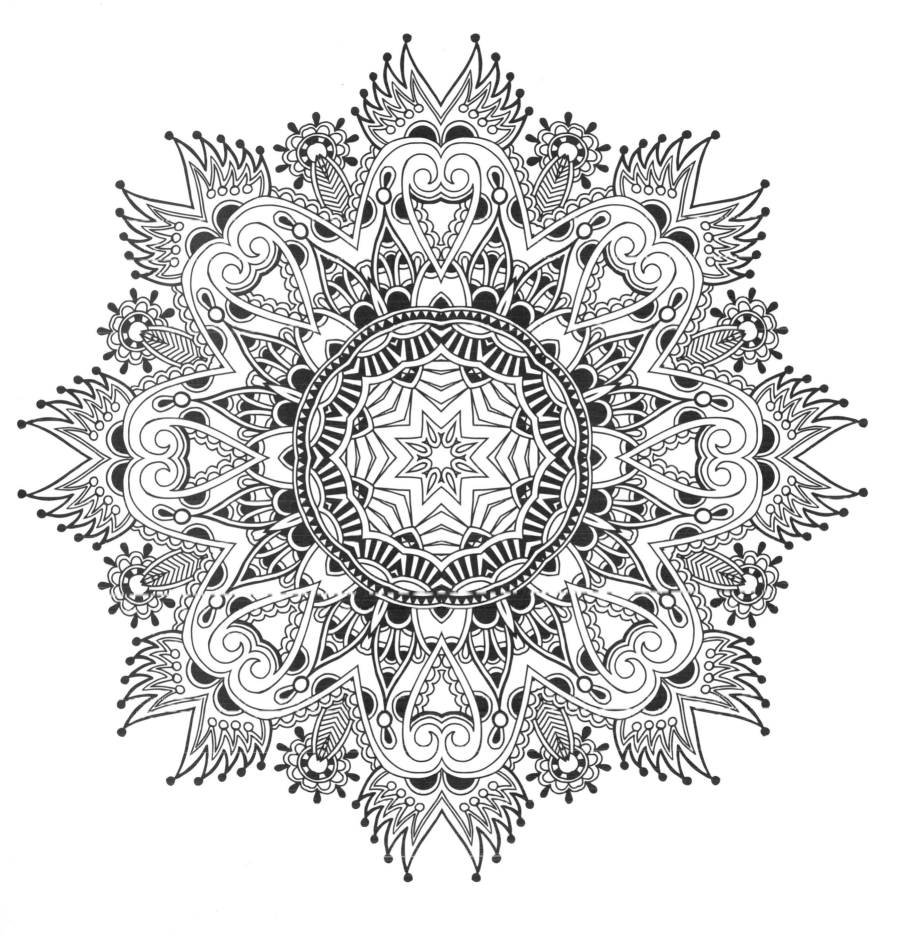

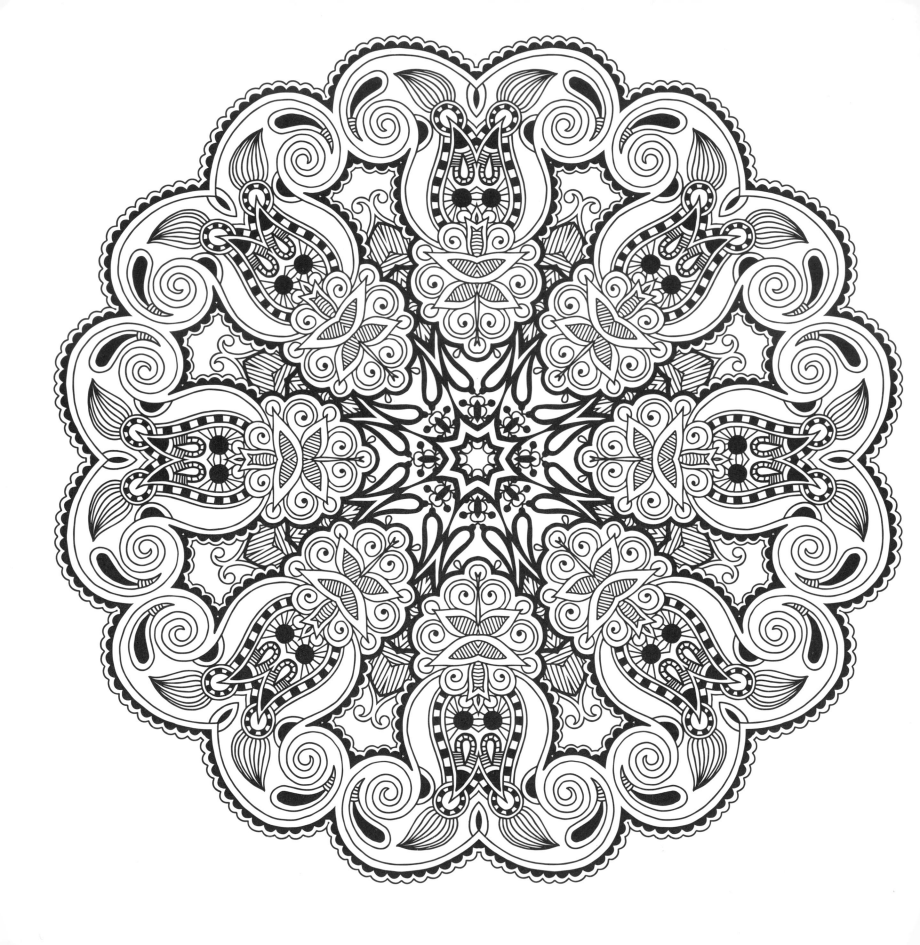

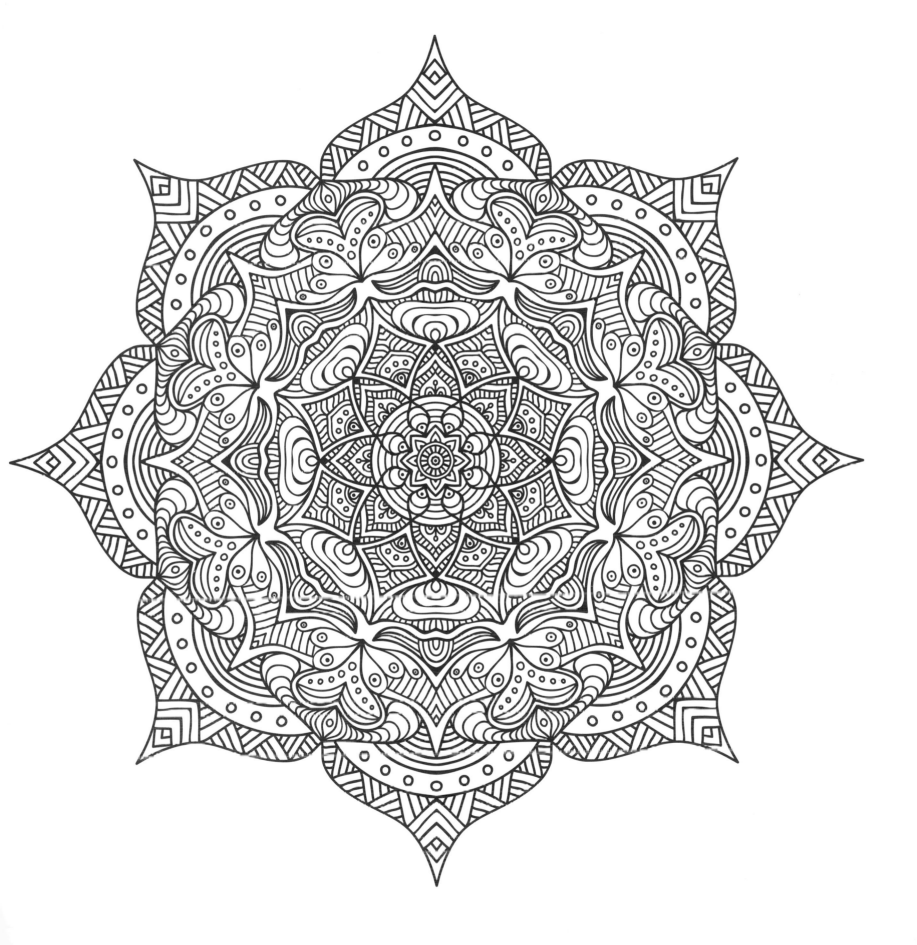

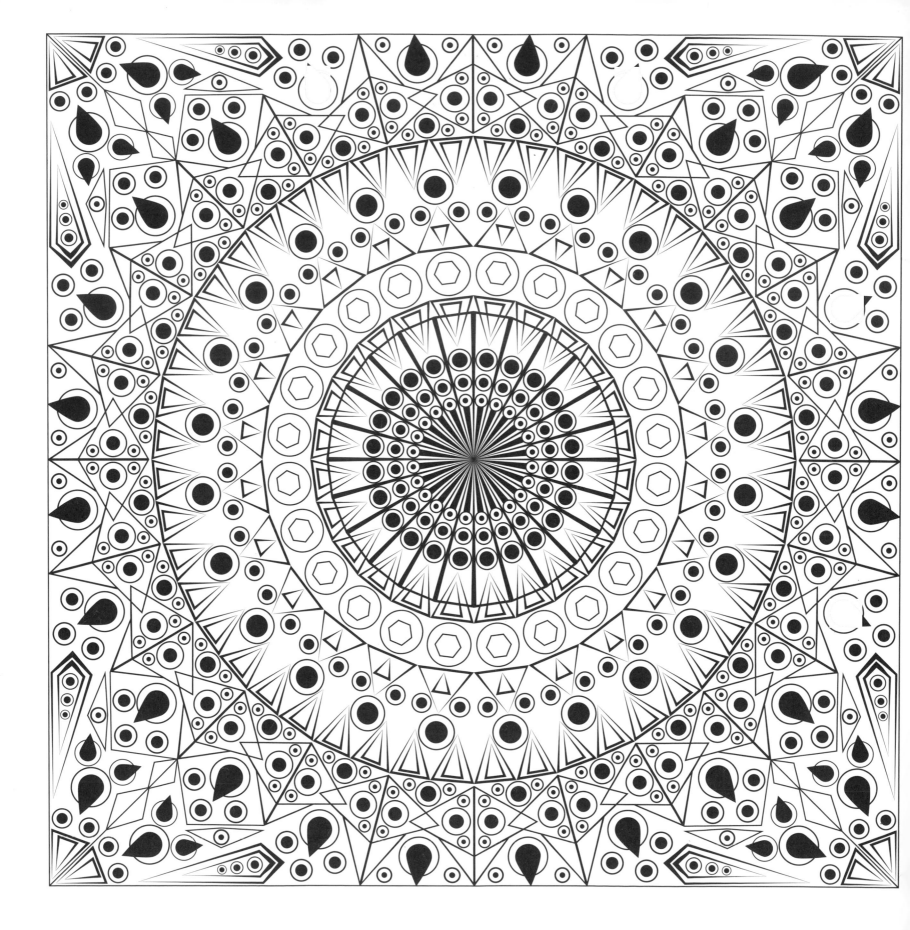

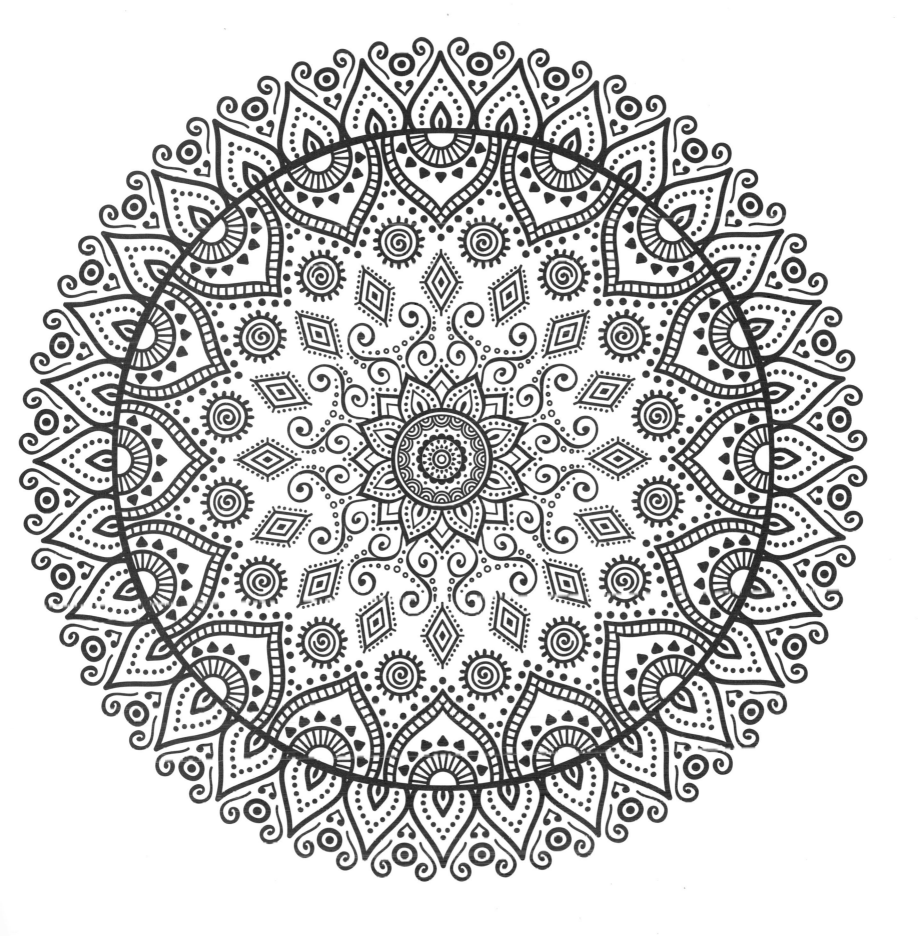

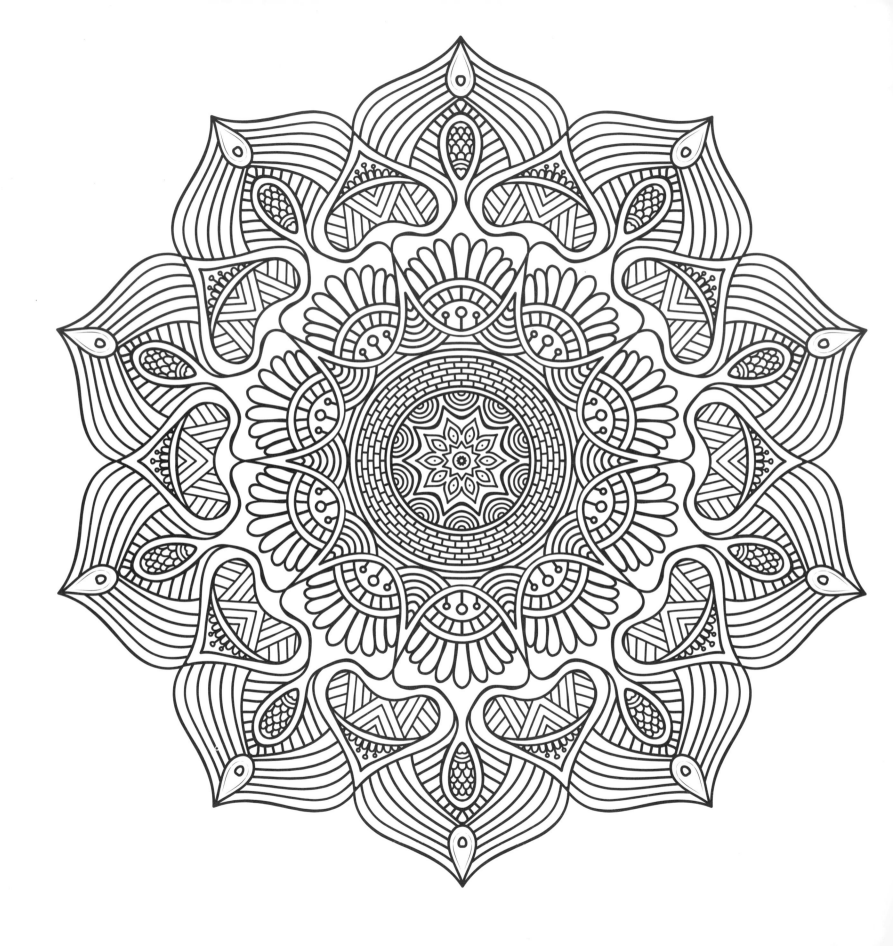

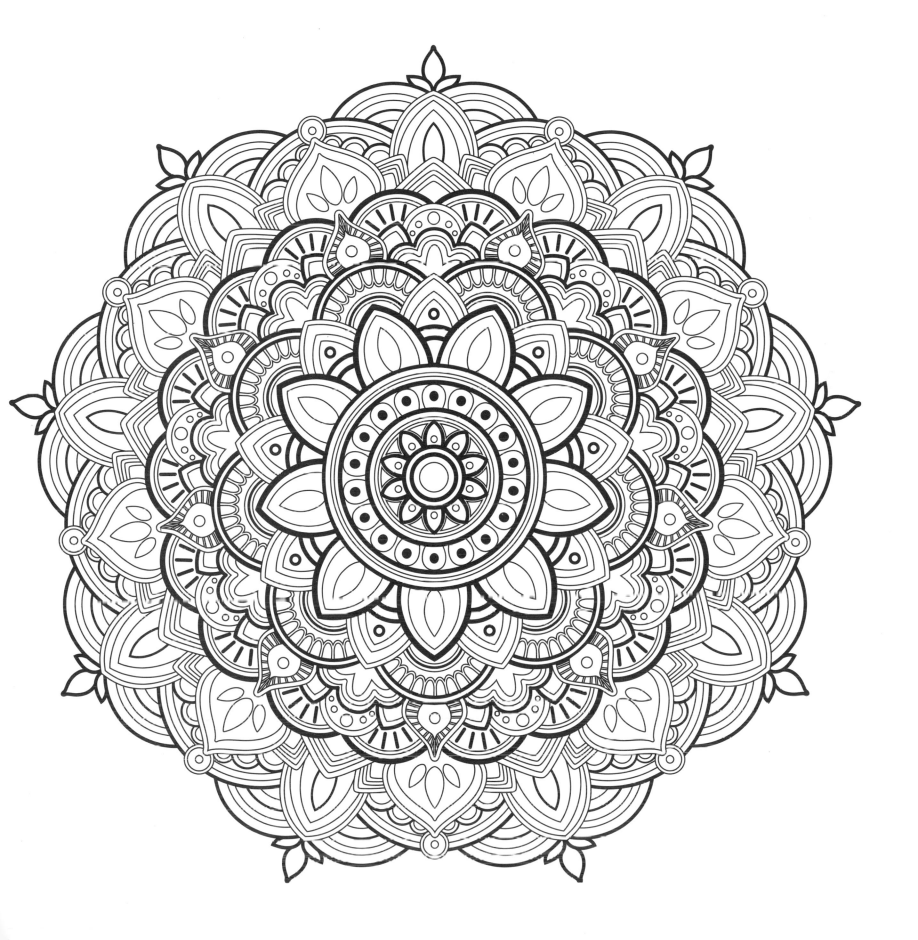

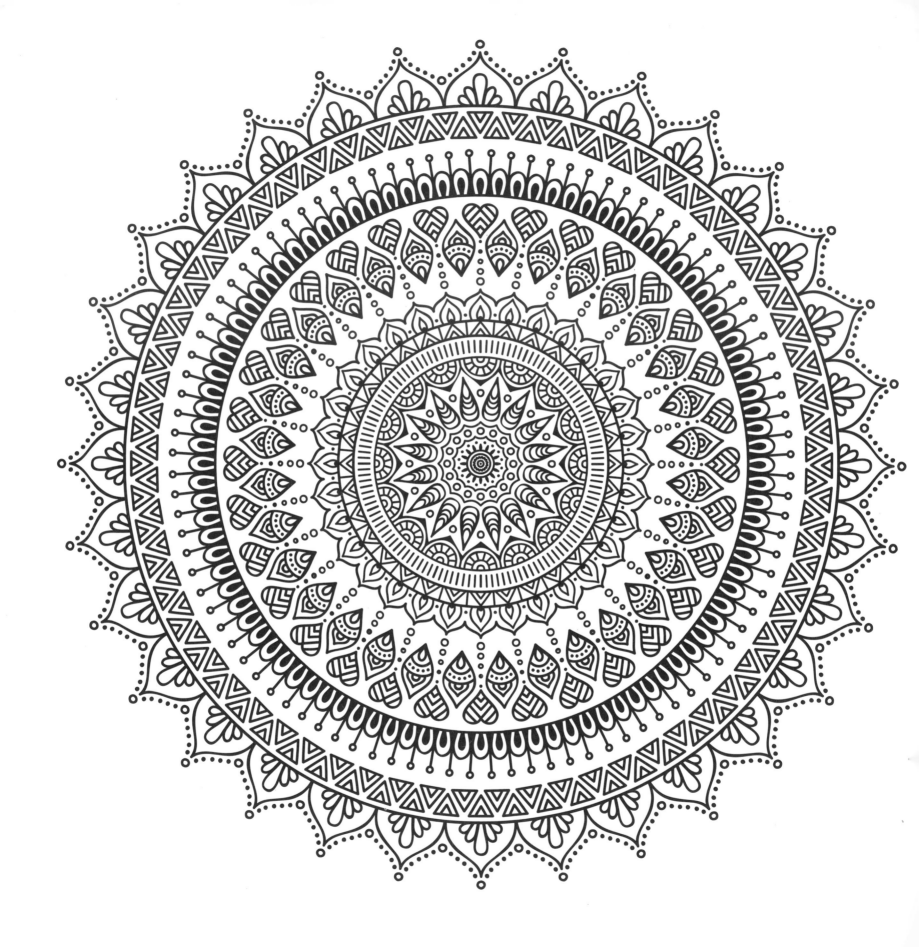

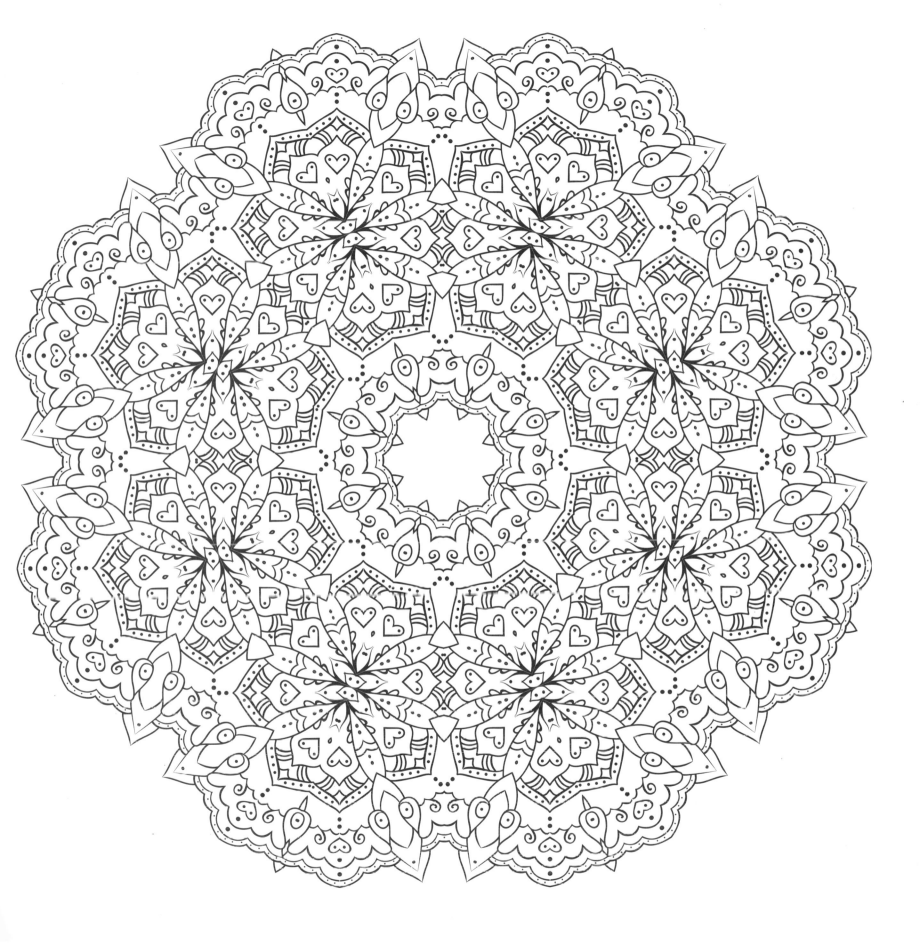

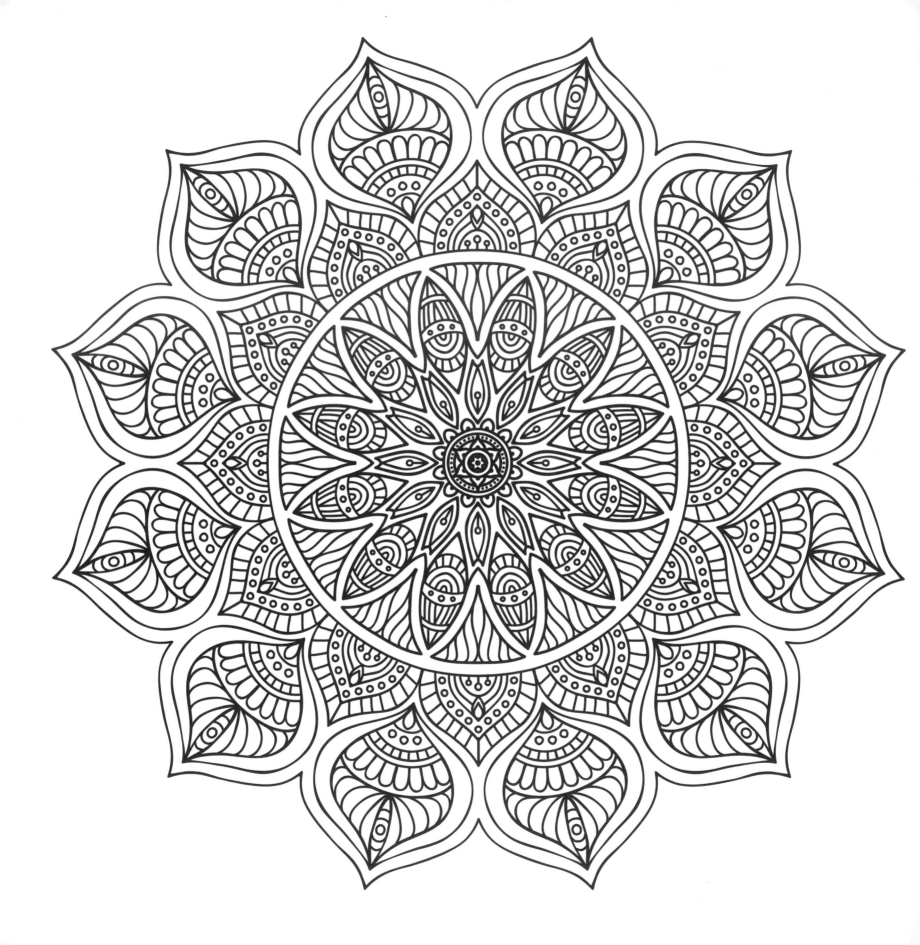

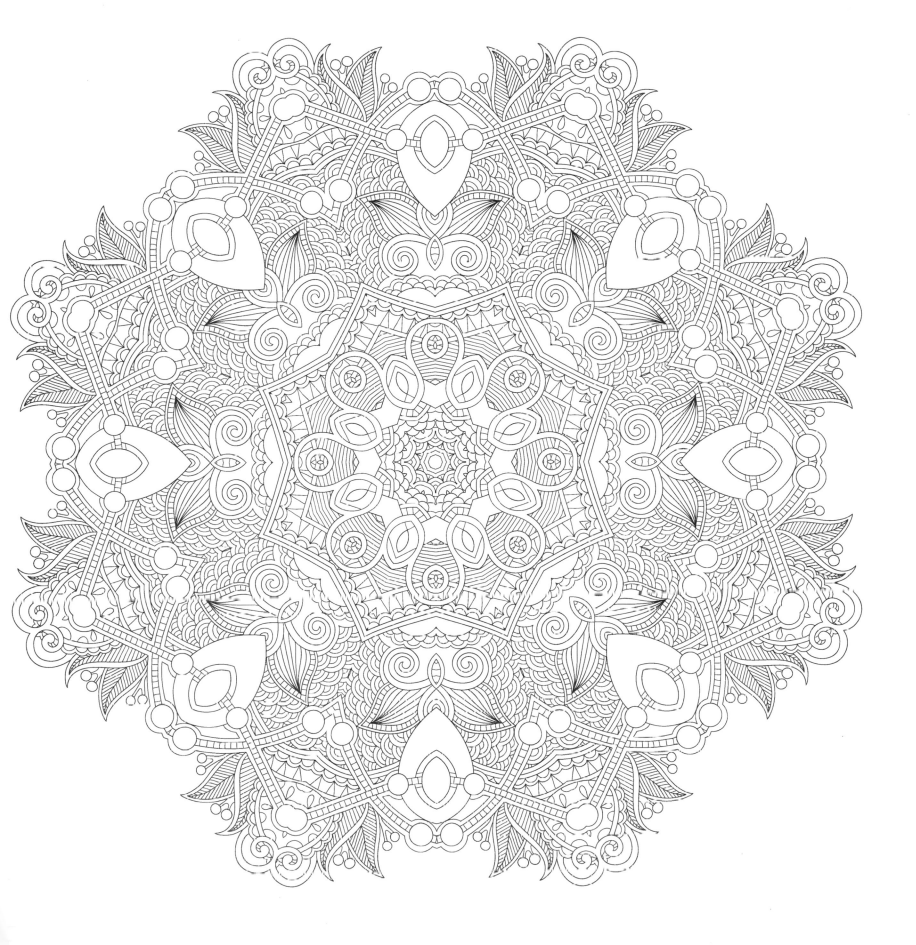

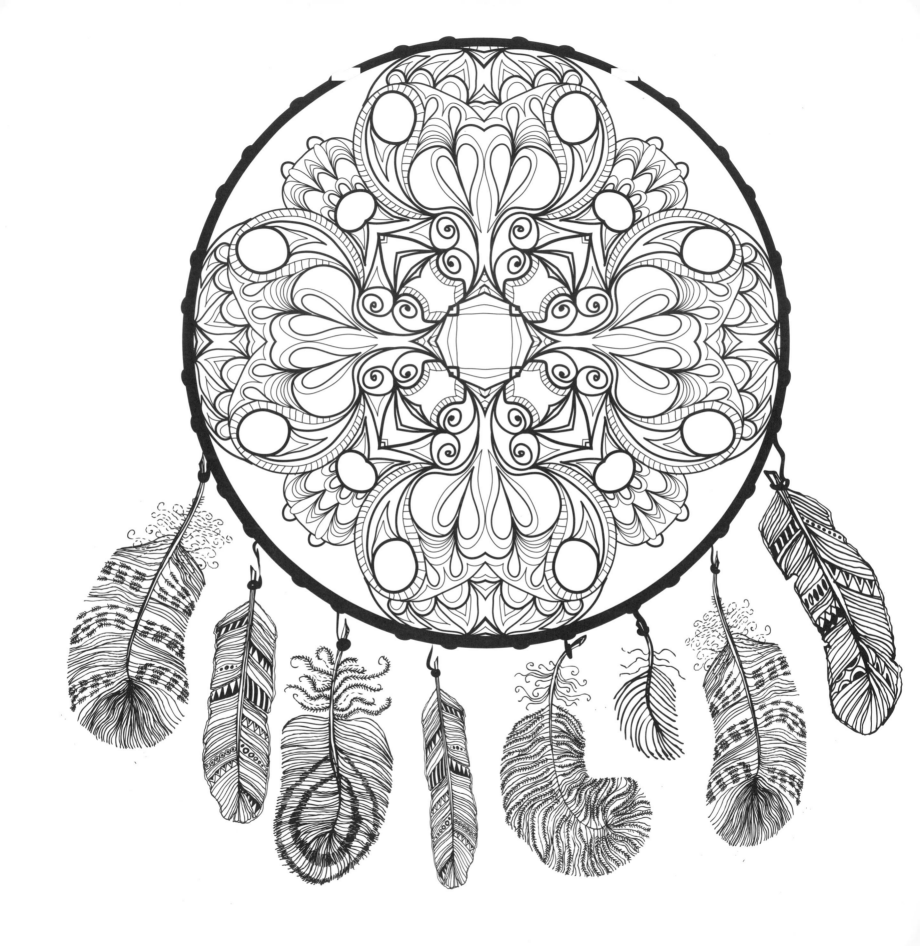

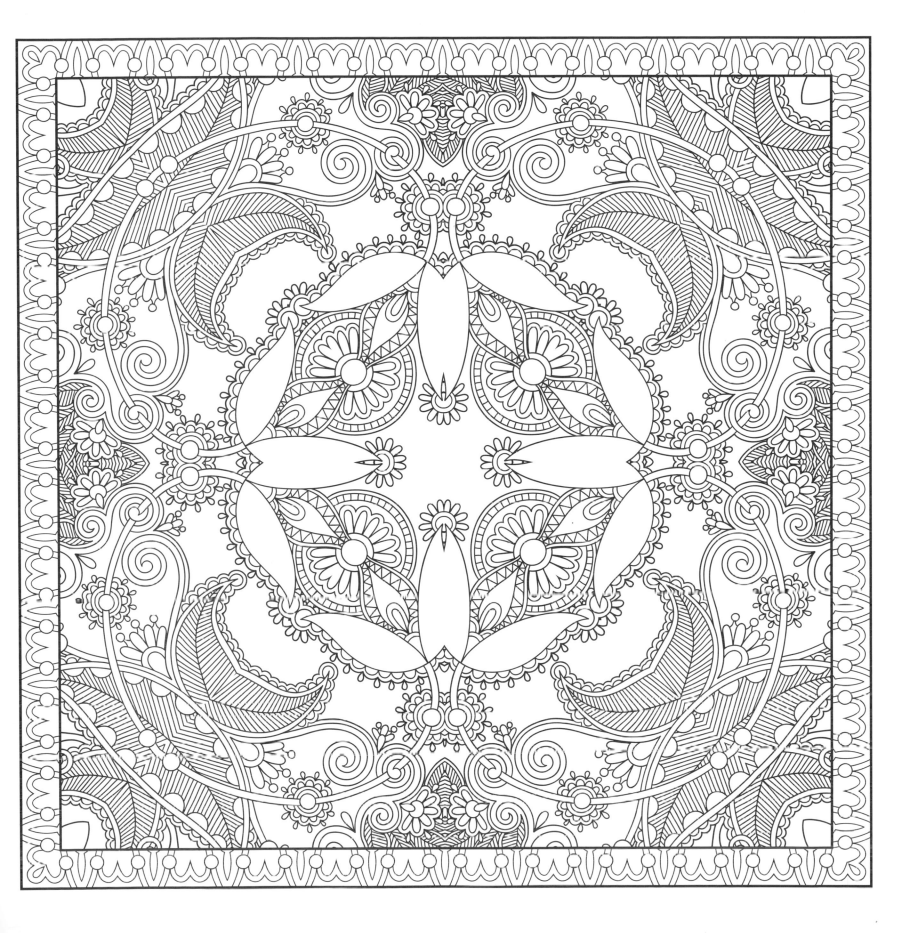

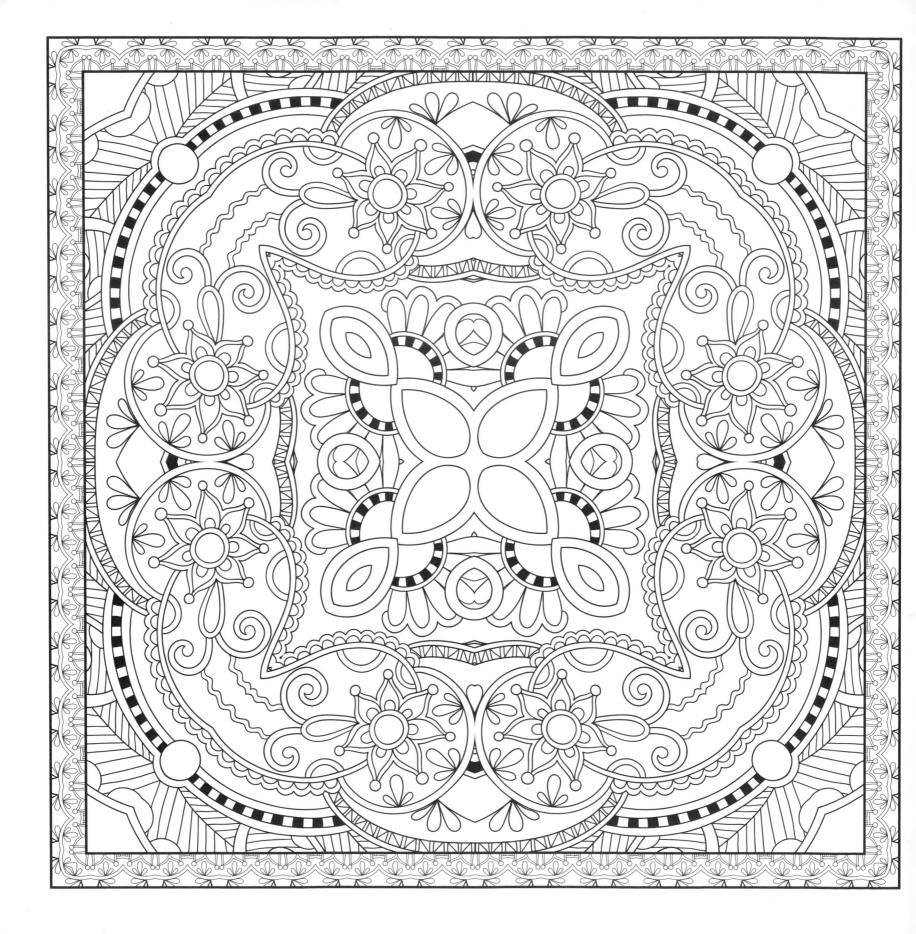

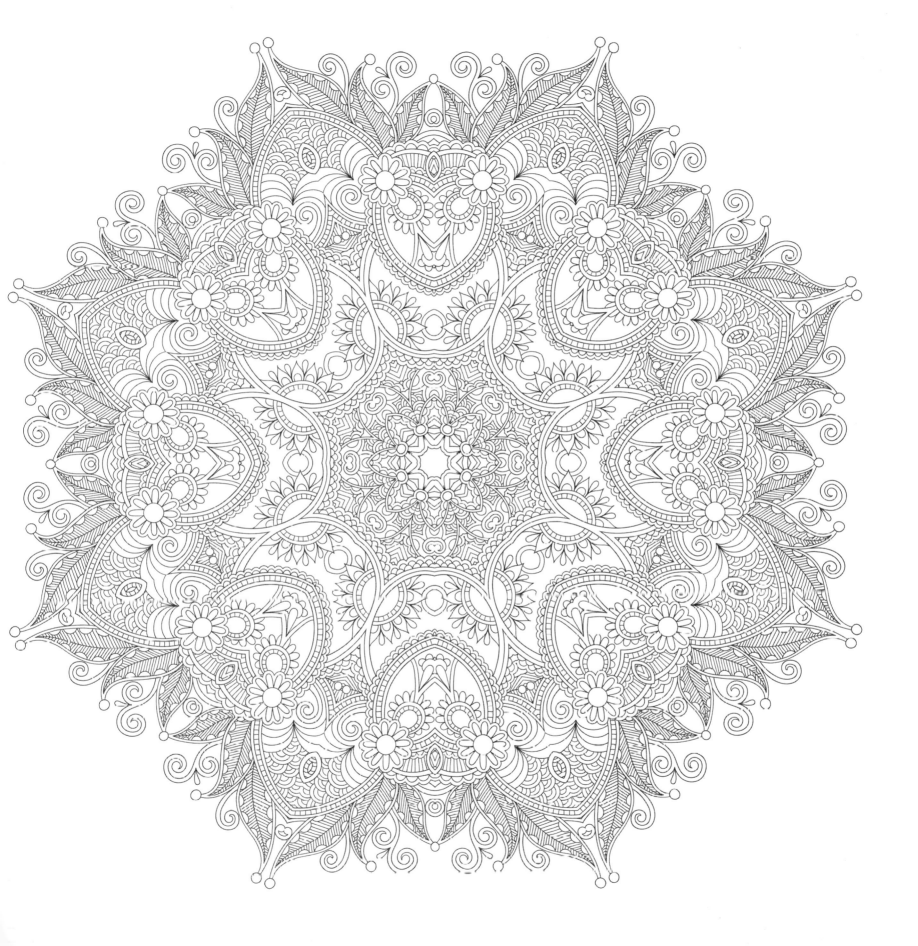

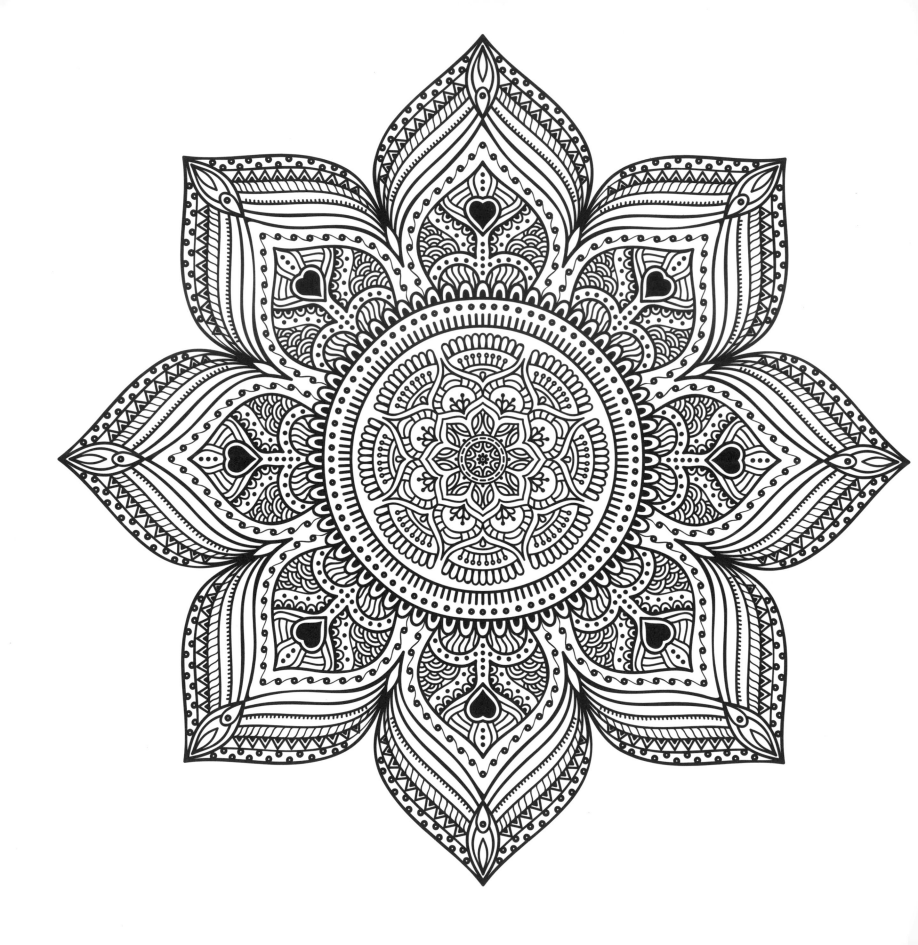

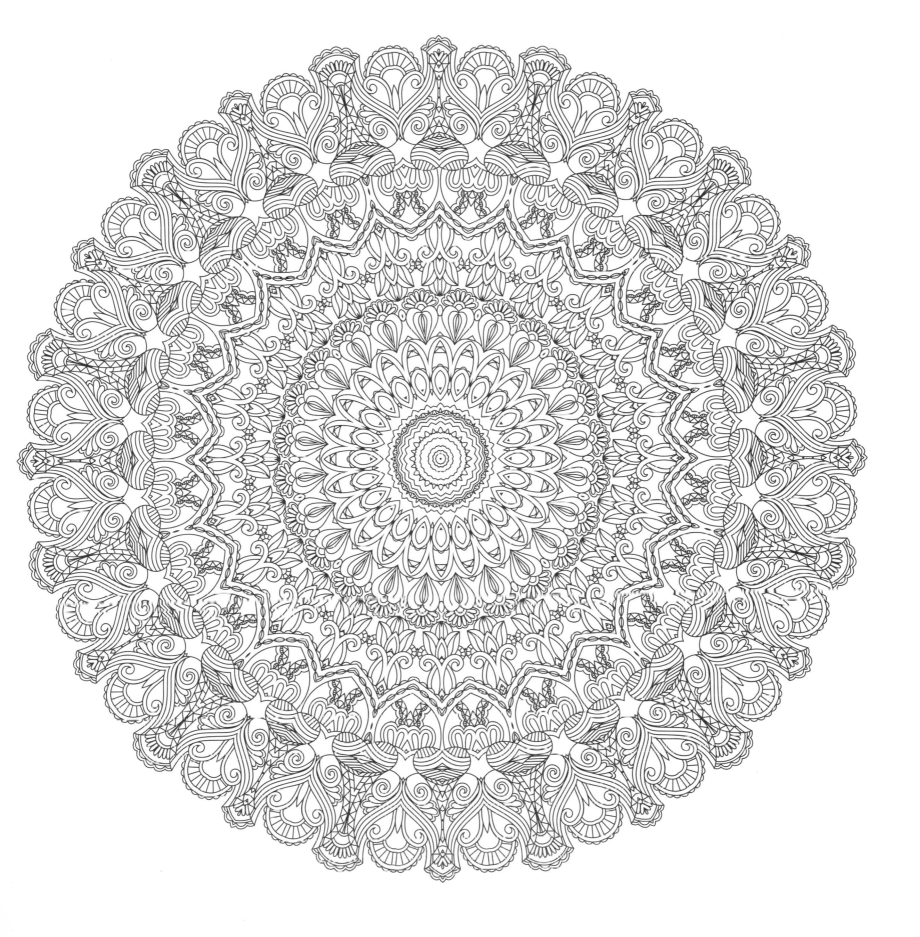

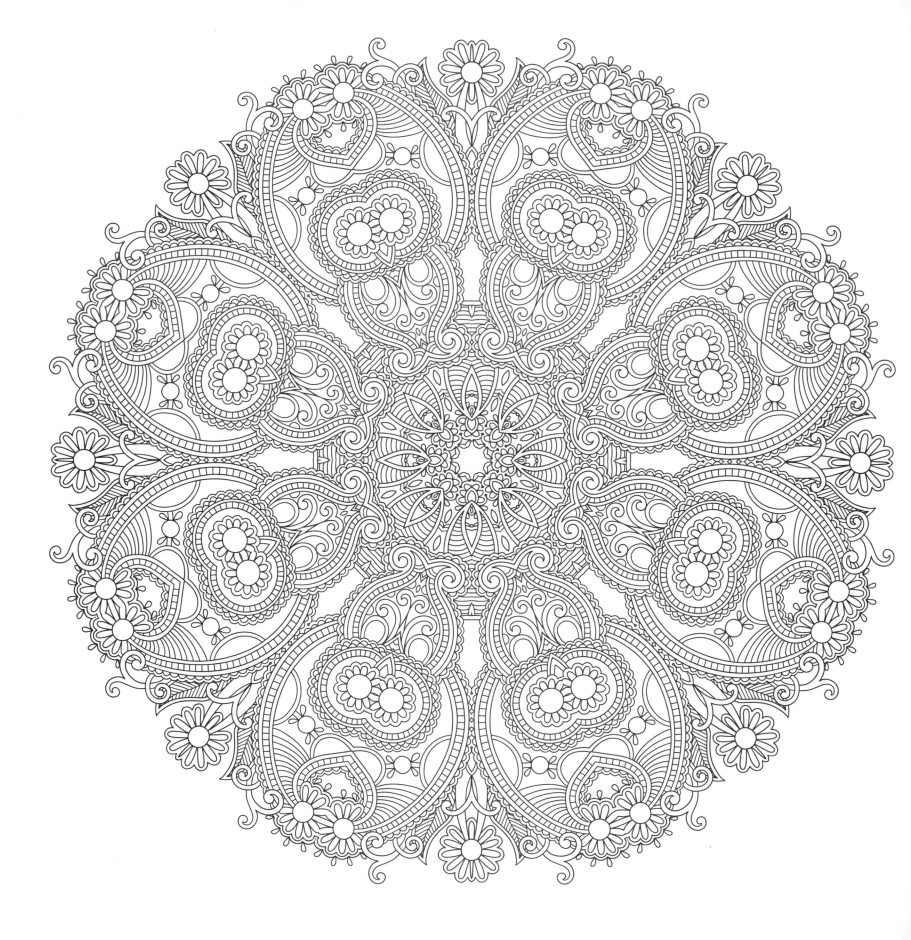

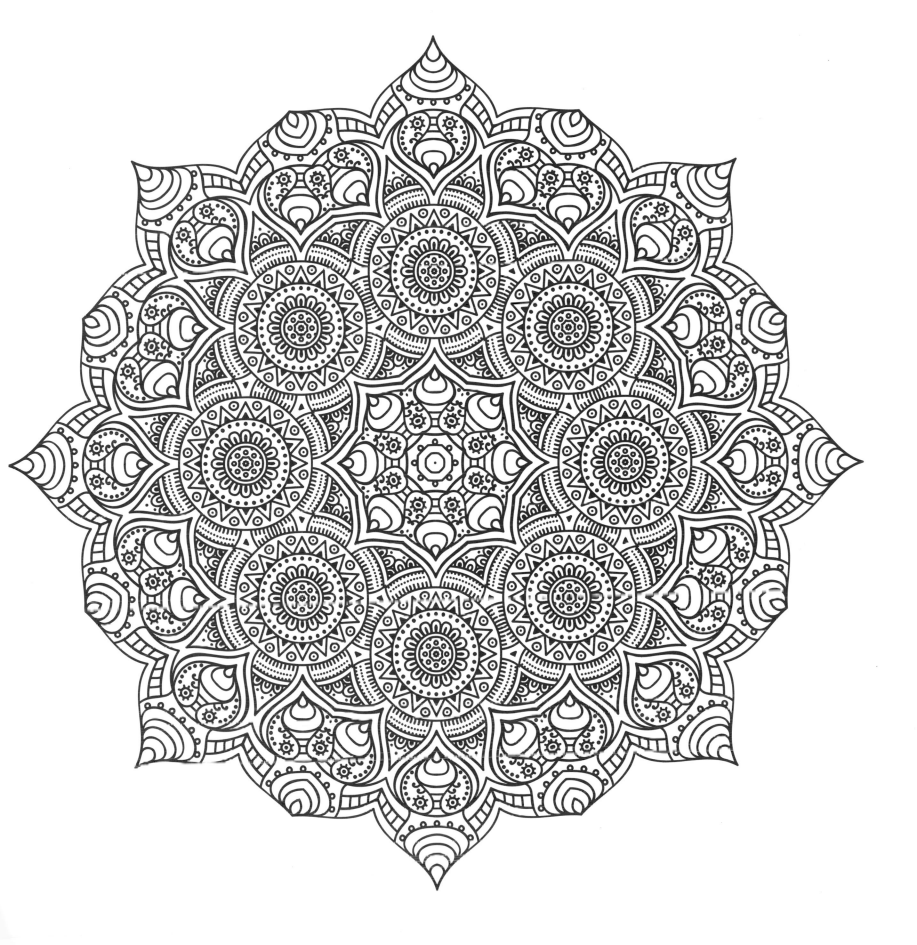

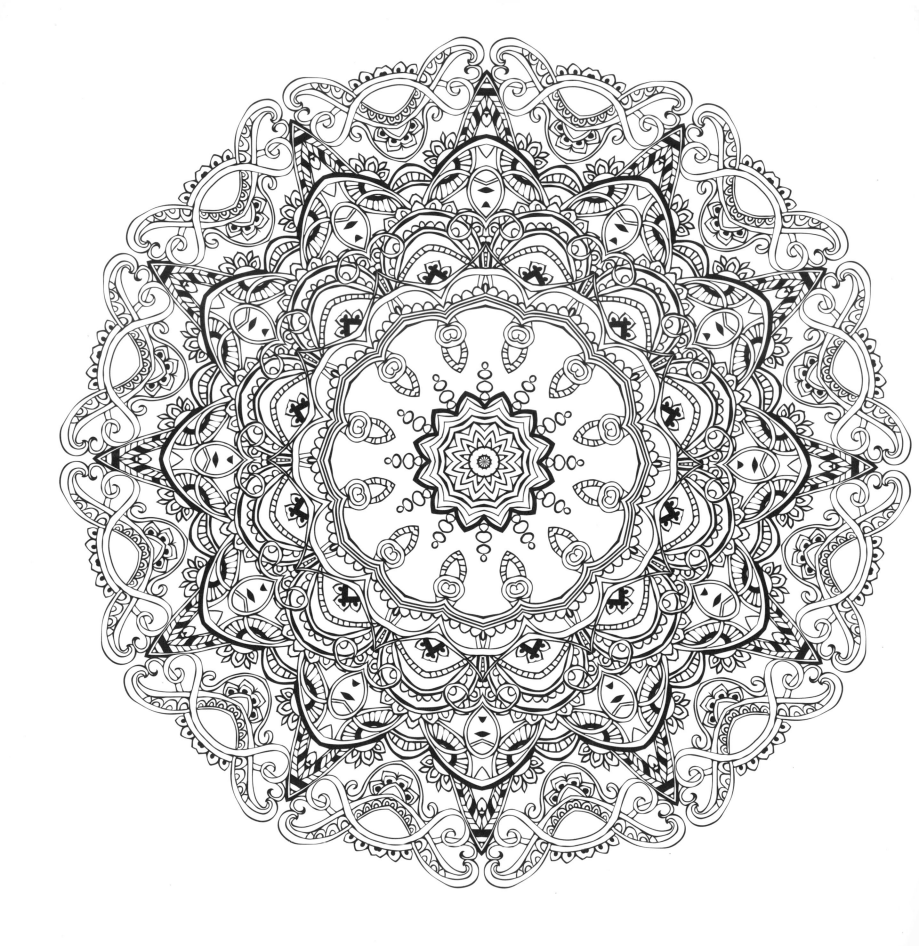

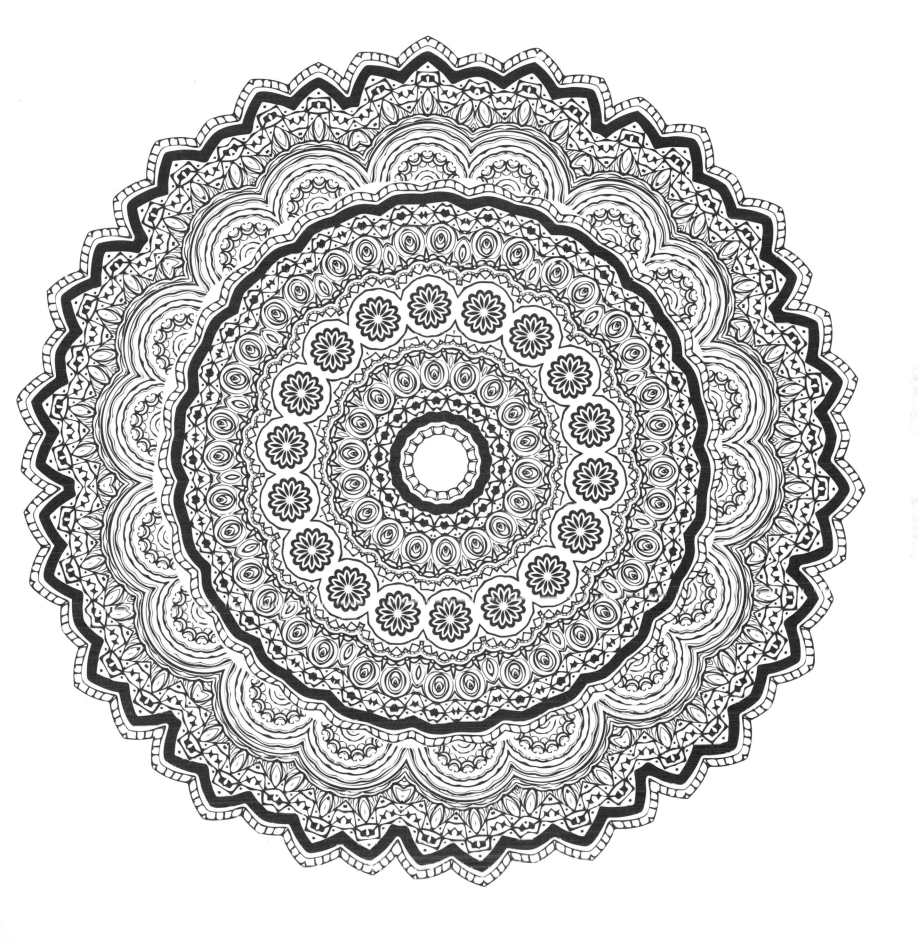

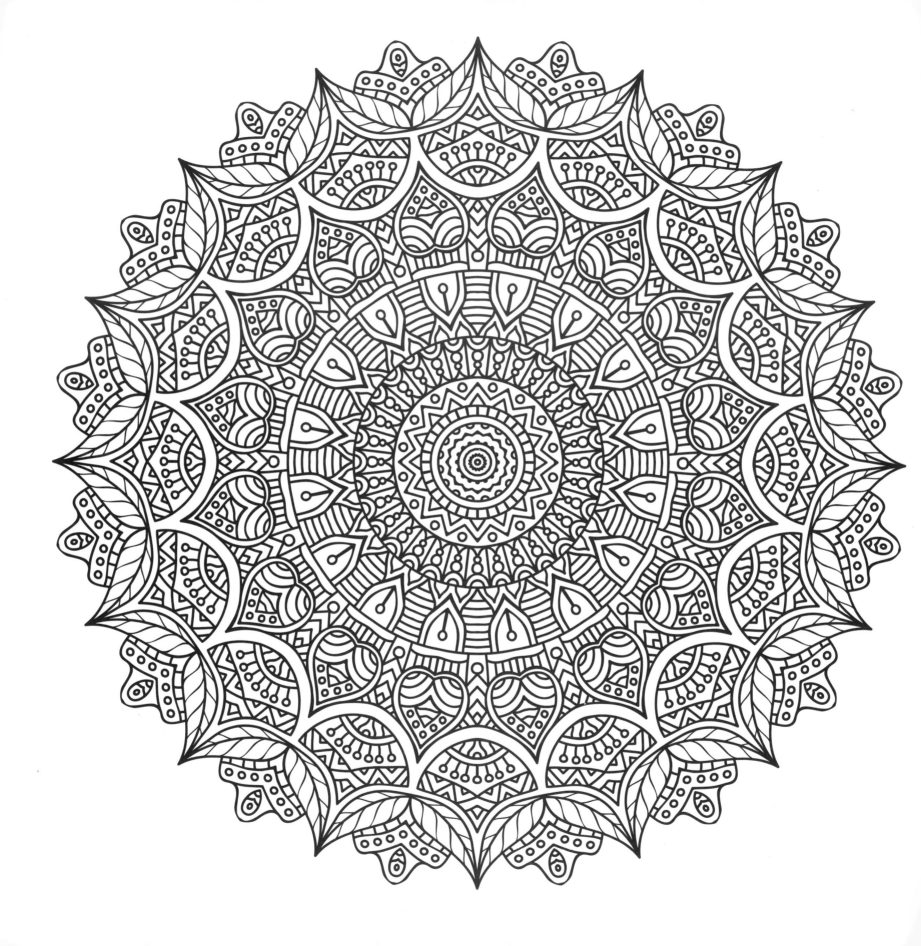

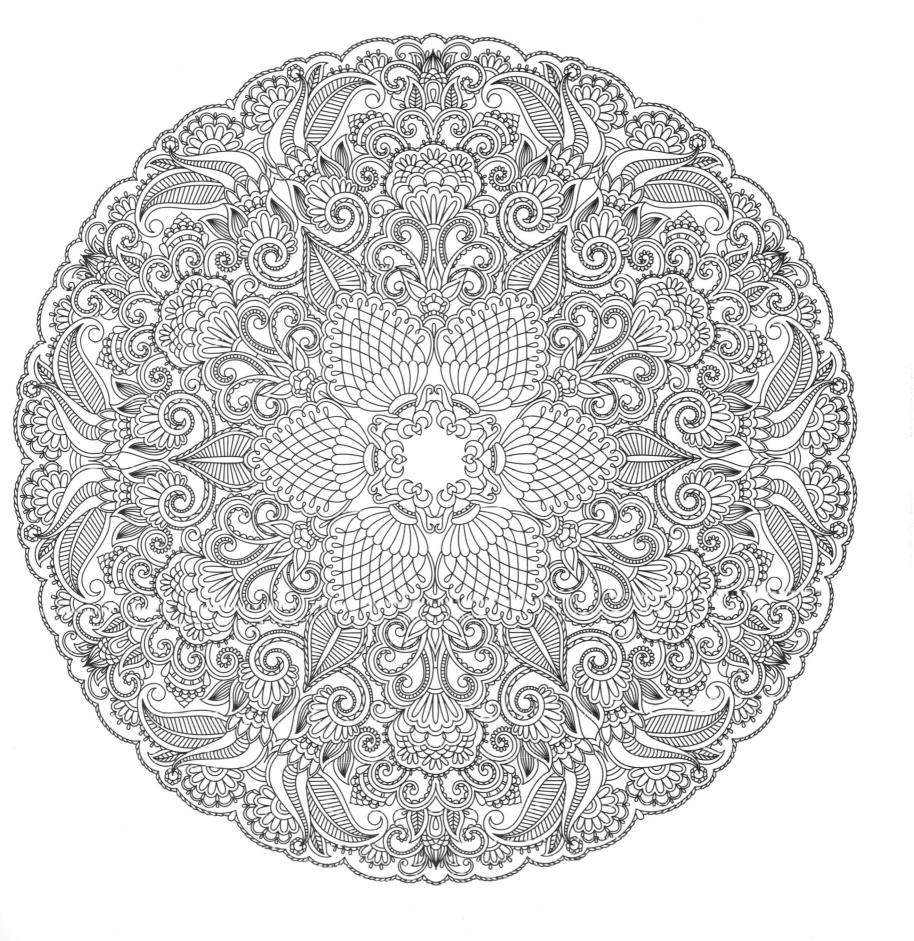

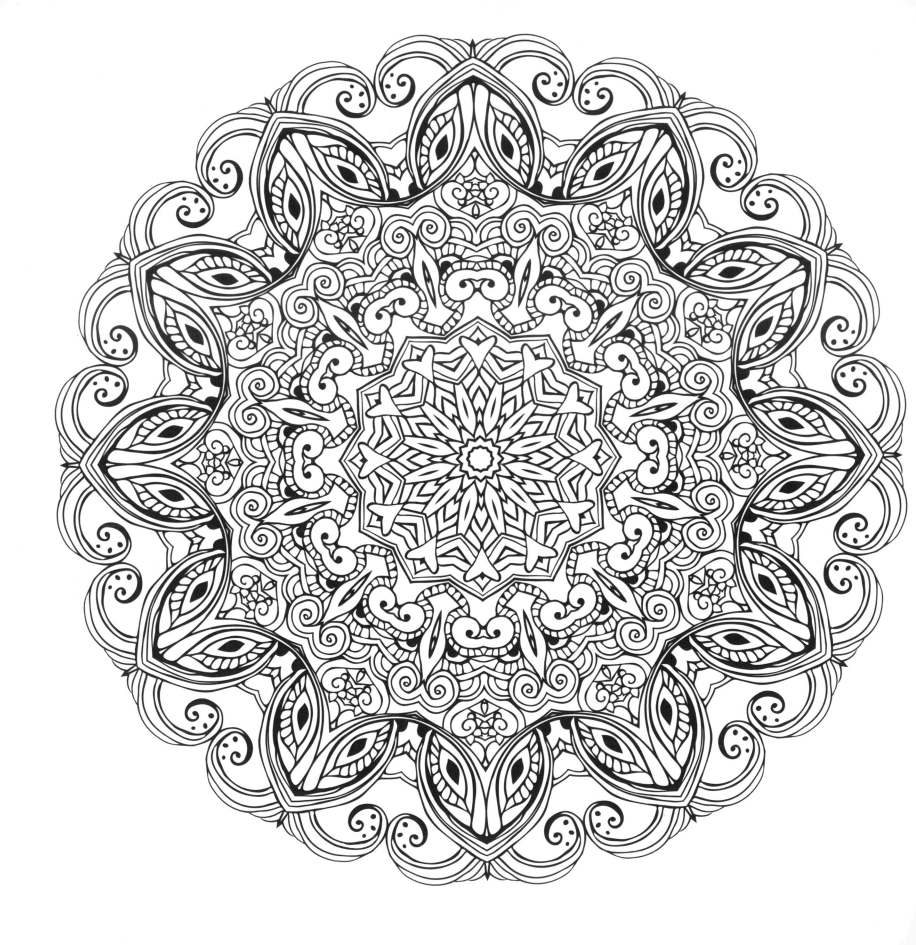

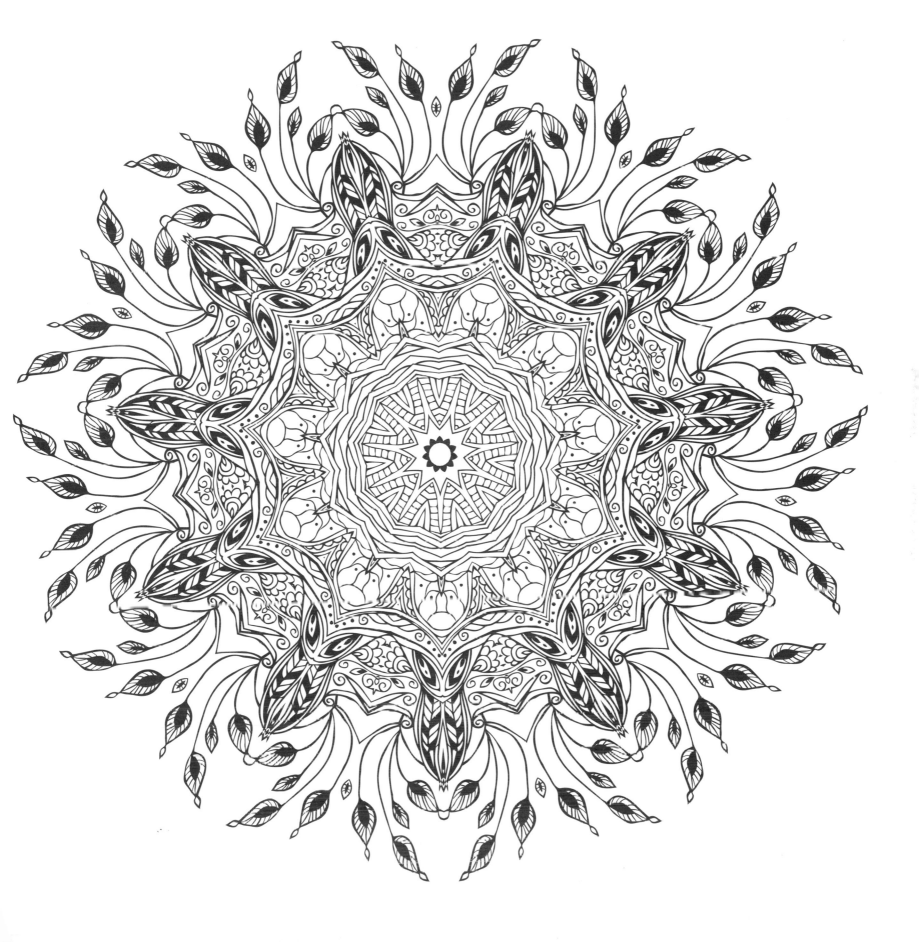

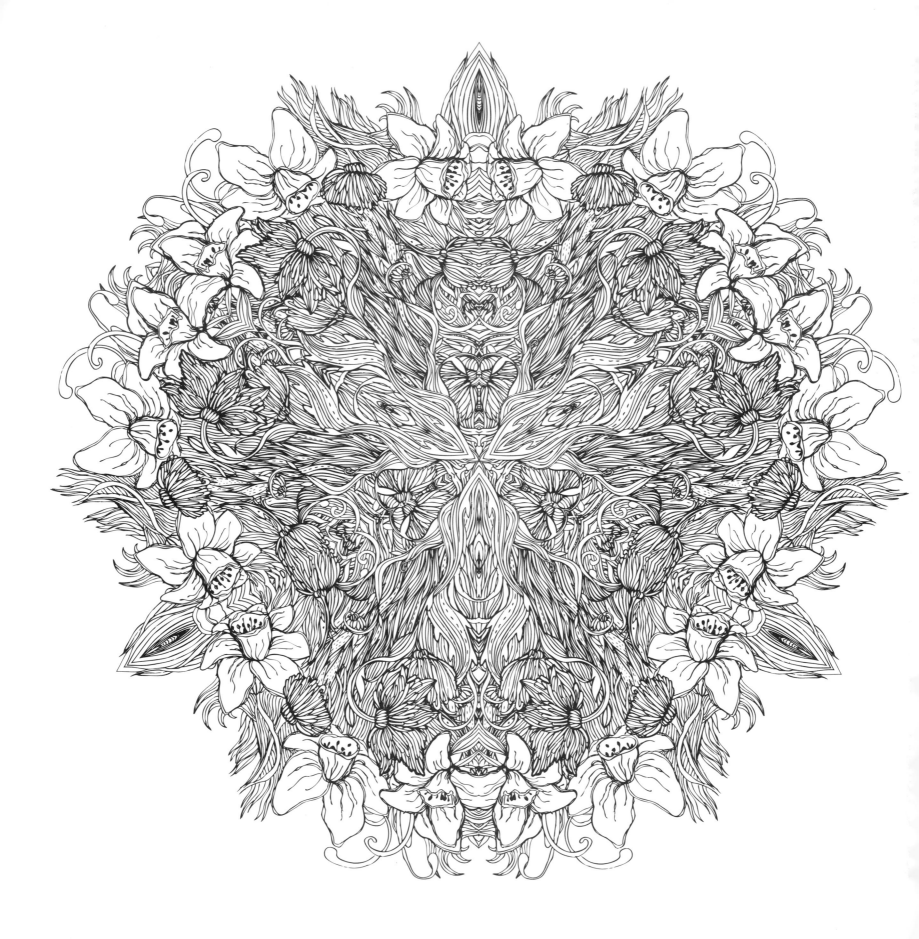

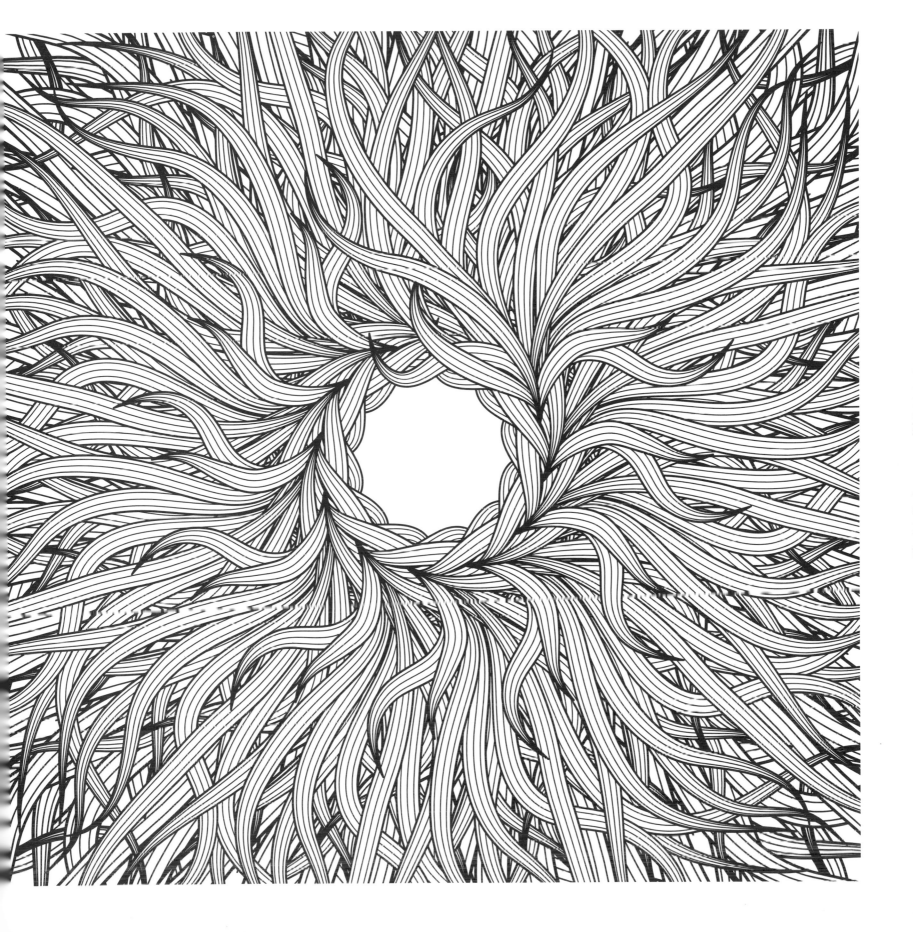

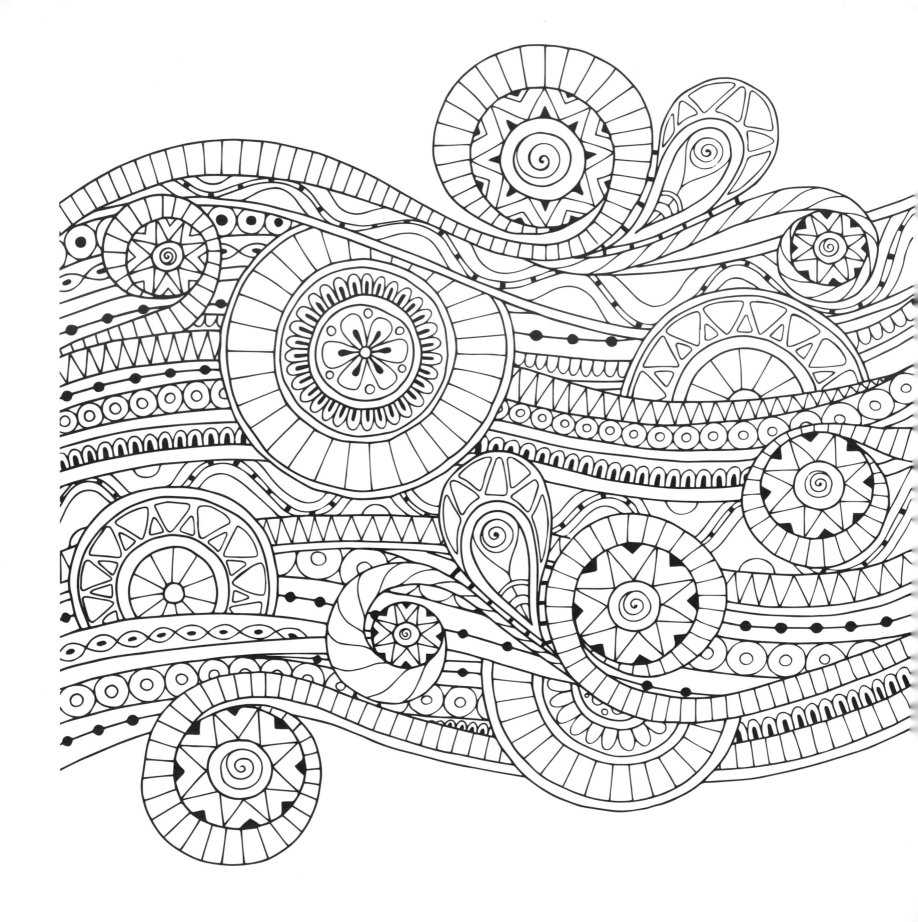

ART CREDITS

Endpapers: © Julia Snegireva/Shutterstock

Interior: In order from first page to last (excluding pages with text only):

© karakotsya/Shutterstock
© Anna Chelnokova/Shutterstock
© Naticka/Shutterstock
© karakotsya/Shutterstock
© zsooofija/Shutterstock
© karakotsya/Shutterstock
© karakotsya/Shutterstock
© karakotsya/Shutterstock
© An Vino/Shutterstock
© karakotsya/Shutterstock
© Snezh/Shutterstock
© Snezh/Shutterstock
© Snezh/Shutterstock
© karakotsya/Shutterstock
© karakotsya/Shutterstock
© elic/Shutterstock
© elic/Shutterstock
© An Vino/Shutterstock
© Marta Jonina/Shutterstock
© Snezh/Shutterstock
© De-V/Shutterstock
© Snezh/Shutterstock
© karakotsya/Shutterstock
© Snezh/Shutterstock
© karakotsya/Shutterstock
© Ira Mukti/Shutterstock
© Snezh/Shutterstock
© karakotsya/Shutterstock
© Snezh/Shutterstock
© karakotsya/Shutterstock
© Snezh/Shutterstock
© kumarworks/iStockPhoto

© karakotsya/Shutterstock
© Snezh/Shutterstock
© karakotsya/Shutterstock
© karakotsya/Shutterstock
© Snezh/Shutterstock
© karakotsya/Shutterstock
© Snezh/Shutterstock
© Benihime/Shutterstock
© Snezh/Shutterstock
© Natalypaint/Shutterstock
© karakotsya/Shutterstock
© Ali Riazi/Shutterstock
© karakotsya/Shutterstock
© karakotsya/Shutterstock
© karakotsya/Shutterstock
© karakotsya/Shutterstock
© karakotsya/Shutterstock
© karakotsya/Shutterstock
© karakotsya/Shutterstock
© karakotsya/Shutterstock
© karakotsya/Shutterstock
© art_of_sun/Shutterstock
© karakotsya/Shutterstock
© karakotsya/Shutterstock
© An Vino/Shutterstock
© karakotsya/Shutterstock
© karakotsya/Shutterstock
© karakotsya/Shutterstock
© Benihime/Shutterstock

© karakotsya/Shutterstock
© karakotsya/Shutterstock
© karakotsya/Shutterstock
© Snezh/Shutterstock
© Sayanny/Shutterstock
© Snezh/Shutterstock
© Snezh/Shutterstock
© Real Illusion/Shutterstock
© Snezh/Shutterstock
© Ira Mukti/Shutterstock
© Snezh/Shutterstock
© karakotsya/Shutterstock
© moopsi/Shutterstock
© karakotsya/Shutterstock
© karakotsya/Shutterstock
© karakotsya/Shutterstock
© Snezh/Shutterstock
© Naticka/Shutterstock
© karakotsya/Shutterstock
© Snezh/Shutterstock
© An Vino/Shutterstock
© An Vino/Shutterstock
© Snezh/Shutterstock
© Anna Chelnokova/Shutterstock
© An Vino/Shutterstock
© An Vino/Shutterstock
© Gorbash Varvara/Shutterstock
© Snezh/Shutterstock
© Julia Snegireva/Shutterstock
© Julia Snegireva/Shutterstock